HOW TO PHOTOGRAPH
PEOPLE

HOW TO PHOTOGRAPH PEOPLE

DEMETRIUS FORDHAM

ilex

INTRODUCTION

1 THE BASICS

2 TYPES OF PORTRAITURE

INTRODUCTION

Photographing people, in my opinion, is the most rewarding kind of photography. What could be a more fascinating, inspiring, and powerful subject than humanity itself? When you take a portrait of someone, you're capturing a part of their unique story, a fleeting moment in a fleeting life. In ten years' time, that person before you will be a different person entirely, from the way they look to their hopes and dreams. In a single snapshot, you've frozen time. I can't think of anything cooler.

I've been obsessed with taking portraits since I was in high school, armed with a beat-up Pentax K1000 I bought at a flea market in Denver, Colorado. Being multiracial (black and white) and multinational (I was born in Germany and raised between Germany and the United States), I'd always suffered with a crisis of identity: I never felt a sense of belonging to any particular culture or country, and so I used portraiture—of myself, my friends and family, and the people around me—to work it out. Taking portraits helped me to see people. It gave me more empathy and compassion and allowed me to understand and celebrate our differences and commonalities.

Fast-forward to today, and I've spent more than a decade photographing people, from advertising campaigns and fashion editorials to magazine profiles and travel features. I've shot personal portrait series, featuring mainly individuals in the BIPOC and LGBTQ+ communities—underrepresented minorities whose voices and faces are still not seen or celebrated as widely as they should be. And through it all, I have only grown more curious about and inspired by humanity: how strong and fragile we are, how unique and yet how similar, how much each of us is capable of enduring. If there's anything I want this book to leave you with, it's not compositional techniques or how to properly light your subject (though I'll get into that), but rather a curiosity, openness and empathy towards others. I think it's impossible to truly capture another human being without taking the time to really see them.

HOW TO READ THIS BOOK

If you're looking for a technical guidebook with step-by-step tutorials on how to take a portrait, this isn't it. Anything you can find on YouTube is probably not going to be in here. Instead, I'll share with you all the most important things I've learned from more than a decade of shooting people, from how to tell a visual story to cultivating a connection with your subject. Rather than ever telling you how to shoot a certain kind of portrait, I'll simply share with you what worked for me, which I hope serves as inspiration rather than instruction.

In Chapter 1, I'll go over all the basics that form a foundation for a beautiful portrait, from composition to setting a scene. In Chapter 2, I'll take you through the different kinds of portrait photography because you're not limited to just one! In Chapter 3, I'll share with you all my tips and tricks for capturing powerful and unforgettable portraits. Then, finally, in Chapter 4, I'll reveal how and where I find inspiration for my own photography, from social media to the masters whose work has influenced mine.

Though this book unfolds in a linear fashion, I certainly don't expect you to read it that way. The best journeys—particularly those in art and photography—are never linear. I hope that you'll pick up this book whenever you're in need of some inspiration, open it to a random page and find something that lights a spark. Or flip through it until you come upon something that speaks to you—a style of photography you might want to try, a technique that sounds interesting, a cool idea. Or read it from cover-to-cover and use it like a textbook. Whatever works for you!

The bottom line: within these pages, you'll find all the knowledge and advice I've acquired in my many years of photographing people. Sitting in your hands right now is everything I know, as of now. I humbly share all of this with you in the hopes that you'll use it to take better pictures of people. But if I'm being completely honest, all you really need to know is this one thing: the secret to taking better pictures of people? Take more. And then more. And then more…

1

THE
BASICS

SUBJECTS
LIGHT
RAPPORT
COMPOSITION
STORYTELLING

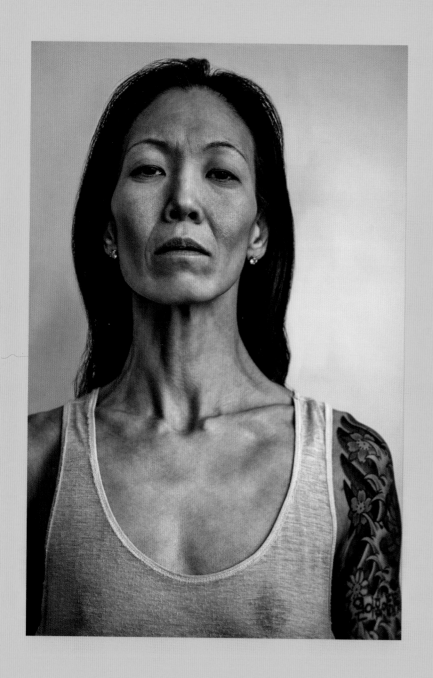

On the surface, portrait photography can seem rather simple: all you really need is a subject and a camera. But to take an effective portrait that honestly captures your subject, tells a story, captivates the viewer and looks beautiful—this requires a little bit more groundwork.

In this chapter, I'll go over all the ingredients that form a solid foundation for an effective portrait. If you were baking a cake, it would be your flour, eggs, milk and sugar. For a really good portrait, you'll typically need to have a solid subject, connection and rapport, good lighting and some understanding of composition.

SUBJECTS

HOW I SHOT IT

Ree is what I consider the ideal subject, striking and complex, with lots of layers. In this portrait, I wanted to coax out the darker and edgier side of her personality, positioning her at the center of a black V-flat, which framed her in shadows. A direct stream of sunlight from a front-facing window added contrast and illumination, so that she wasn't engulfed entirely in darkness. The cigarette wasn't intended, but it ended up working out nicely, adding an extra bit of edge. These portraits were shot with a Canon Mark II using a 50mm prime lens. It was published in *Schön! Magazine* and eventually inspired a larger portrait series on women aged over 50 entitled *Ageless Beauty* (see page 77).

In portrait photography, your subject is the foundation of your picture, its anchor and its base, and so having a captivating subject is vital. In certain cases, such as a commissioned editorial shoot, a family portrait, or a special occasion, your subject(s) will be provided for you, and you won't have a say. Starting with the 'who' and then having to figure out 'how' to shoot them can be a real challenge (if this is your case, see page 74). In other instances, such as a personal portrait project or a series, you'll have the freedom to pick your own subject(s), which offers more creative flexibility. This is where the fun begins!

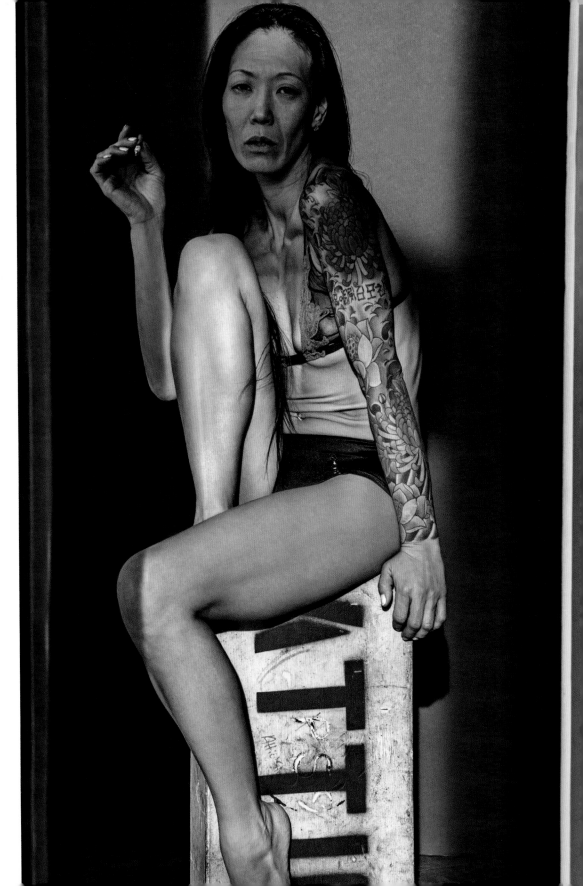

CASTING

When choosing a portrait subject, ask yourself first what kind of portrait you want to take. For example, if you want to shoot an action portrait, you'll want to cast somebody who is comfortable in their body and has a good range of movement. If you're after a more abstract or details-focused portrait, an individual with interesting or distinctive defining features—cool hair, tattoos, freckles—will be the easiest to work with.

If you're just starting out, the process of finding subjects can be really intimidating. Sure, you can ask friends and family, but I've personally found the internet to be the best resource for finding and casting interesting subjects. I often cast subjects for portrait projects through local Facebook groups where photographers and artists can connect with models, or through talent databases that feature models, actors, and artists searching for work and open to collaboration. If you're looking to shoot classic studio portraits or to try your hand at editorial-style shots, you can also contact local modeling agencies and see if they'd be interested in connecting you with any up-and-coming talent for a test shoot. It's a win-win situation: you get subjects and the agency receives portraits.

I've shot hundreds of individuals over the past decade or so, but the subject who always stands out most in my mind is Ree. It was more than just her look—there was an intriguing and commanding energy about her that translated through the photograph. Rather than seeking out someone who is conventionally photogenic, this sort of special, inexplicable X factor is really what you want to look for in a subject—so take your time using the avenues I mentioned above to find the right one.

I was casting for a completely different portrait series on a talent website when I came across Ree's picture. She seemed fierce and powerful yet delicate and soft, and unlike most of the models I was shooting for my fashion work at the time, Ree was older (48). She exuded a rawness, depth and complexity that I found rare. I knew immediately that this was who I wanted to photograph. Similarly, when you're considering a subject, ask yourself what draws you to them, and that exercise will lead you to their essence and the 'thing' you want to capture.

HOW I SHOT IT

When I met Ree in person and heard her story, I knew I wanted to keep her portraits as minimal as possible so that her essence would shine through. I posed her against grey seamless paper to keep the background clean and unobtrusive, and I lit her features naturally by positioning her directly before a window that was casting soft afternoon light. I added a touch of strobe lighting to capture additional detail and placed a black V-flat to her left (camera right) for slight negative fill and shadow. To further enhance the strength and confidence she exuded, I shot her from below eye level so that she towered over me slightly. Most of the portraits we took were more edgy, dark, and gritty, so I thought this white linen dress played up her softness and femininity and made for a nice juxtaposition to her sleeve tattoo.

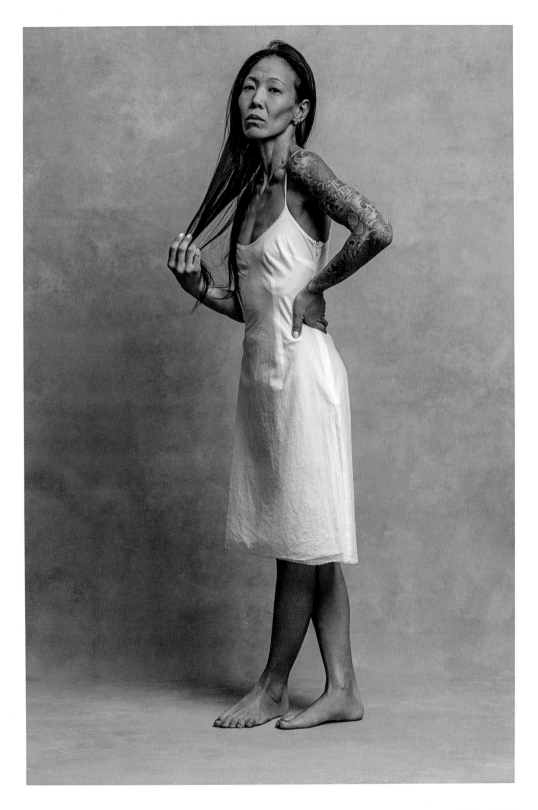

LIGHT

Light is everything in photography, but especially in portraiture. It determines brightness and darkness, mood and emotion, clarity and tone. The source of light, the strength of that light, and where it's coming fro, all affect how your subject appears. Natural, front-on light will bathe your subject's face with even, flat, soft luminance, whereas side lighting will cast shadows and give your subject a more dramatic and mysterious look. Knowing how to light your subject is key to an effective portrait.

I'm not going to go into the technical aspects of lighting here—it's easy enough to find specific setups online with a quick Google search. Unless it's required by a client, you don't need expensive lights or complex setups to take a good portrait. All you really need to know is how light falls and how to shape and manipulate it; the best way to do that is to play with it as much as you can. The following methods are some of my favorite ways to use light in portraiture, some of which go against traditional lighting 'rules'.

USE WINDOW LIGHT

I almost always use window light when shooting a portrait, even if it's in a studio. I love its soft quality and the way it wraps around the skin and illuminates subjects in the most flattering way. In fact, even when I employ artificial light, I try to replicate window light, which is, after all, a big, natural soft box! I also get super excited when I walk into a photo studio with big, warehouse-style casement windows, or when the windows feature thick grilles or designs. Don't be afraid of these: when the light streams through, it will cast cool patterns and shadows into the frame and will almost always add a little something to a portrait.

USE NEGATIVE FILL

When photographers talk about lighting, it's usually about additive lighting; it seems almost counterintuitive to remove light from a portrait. And yet, it's a technique I use in almost every portrait to boost contrast, make blacks deeper and richer, and render shadows more dramatic. By taking away light instead of adding it, you're bringing visual dynamism to your portrait. The best way to do this is with a 4x4 floppy flag or flag on a C-stand placed by the side of your subject where you want to create more shadow and depth. You can also use the black side of a V-flat—even a sheet of black fabric or paper would do. The effect can be subtle, but I've found it can really make a difference to the overall portrait.

SHOOT INTO THE LIGHT

Photographers are typically advised against shooting into the light or directly into the sun because it can result in a dark, backlit subject. But I think it looks cool when used with intention. Shooting into the light can give your portraits the following effects:

- Striking silhouettes, particularly outside during dawn and dusk. Make sure to expose for the background. Silhouettes also work beautifully for action portraiture (see page 68).
- Rim lighting, or a halo of light, surrounding a partially backlit subject.
- Lens flares, which add dreaminess and drama to a portrait.

The bottom line: play with light! Shoot in front of a window for a beautiful, soft, natural look. Employ negative fill to add drama and contrast. Use a strobe and modifiers if you want a little bit more control. Shoot in low light for a moody, cinematic feel. Use backlighting for something completely different. I strongly encourage you to try lighting setups on yourself to learn what works (see page 106).

HOW I SHOT IT

In this portrait of Kevin, I used two of these techniques: window light and negative fill. I positioned him next to the casement windows, just beyond the direct stream of light, which allowed the seamless background to absorb the harder light and window patterns while still bathing Kevin in soft, diffuse light. To his left (camera right), I placed a black V-flat to add depth and detail to his features. I shot this portrait using a Leica SL with a 24–70mm lens, which allowed me to maintain a constant aperture as I zoomed and shot both wide and tight portraits.

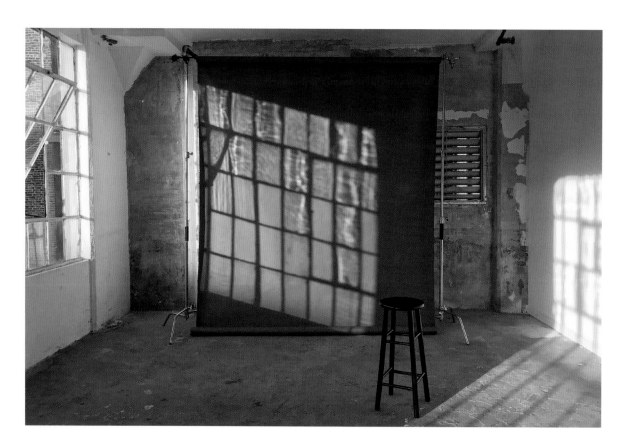

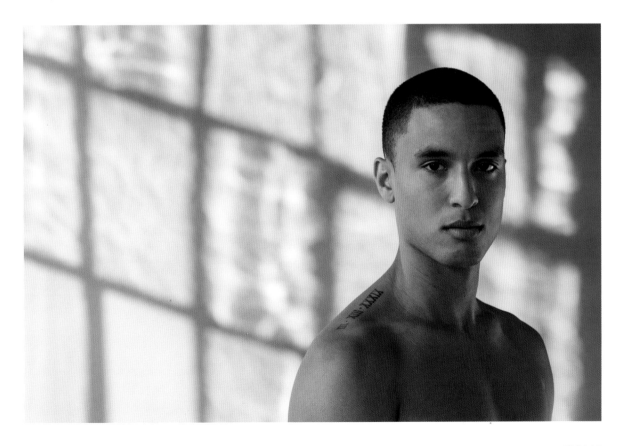

RAPPORT

Making your subject appear natural, effortless, and authentic is key to an effective portrait; but they must feel comfortable and at ease first, which requires genuine a rapport.

Building a rapport with your subject is a photographic skill that's often overlooked in favor of lighting or compositional techniques. In my experience, cultivating rapport is as important as—if not more than—any technical skill. It doesn't matter how captivating your subject is, how beautiful your lighting, or how perfect your composition: if your subject looks stiff, awkward, and uncomfortable, the portrait simply won't translate.

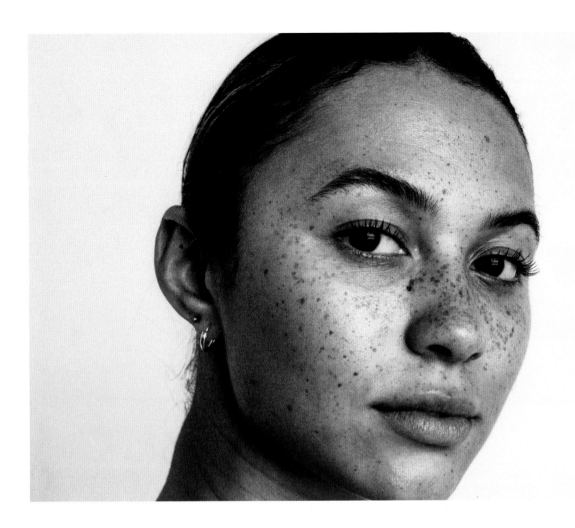

ENVIRONMENT

I've discovered over the years that building rapport does not necessarily mean you have to talk a lot. Something I do before every shoot is email the subject to ask what music they like and what their favorite snacks are, just two simple questions. Then, before they arrive at the studio, I make sure I have a playlist of their favorite tunes streaming and their preferred snacks on hand. I find that those two tiny gestures help models to relax and create a warm, friendly, and hospitable environment—the perfect foundation for developing genuine rapport.

HOW I SHOT IT

I had initially wanted to shoot classic studio portraits of Alex sitting center-frame on a stool, but she had such great features and such a bright, effervescent personality that I thought some tighter, less structured shots would make for more a honest portrait. I ditched the grey seamless backdrop I'd planned to use and instead used the raw white walls of the studio as the background, lighting her using only front-facing window light with a V-flat to her right (camera left) to bring out some of the freckles and details in her face. I shot these images with a Nikon D800 and an 85mm prime lens.

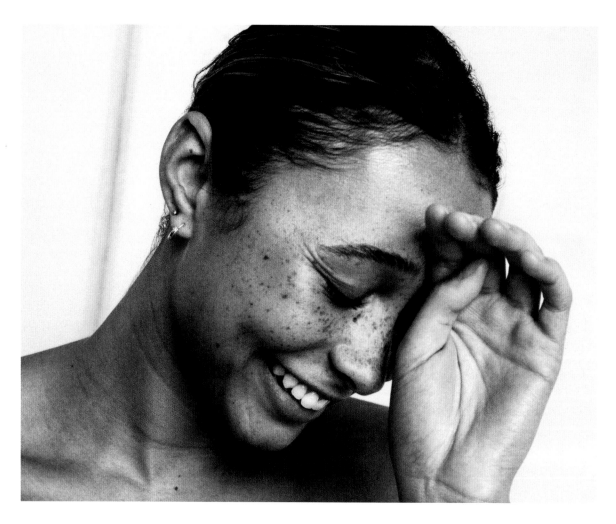

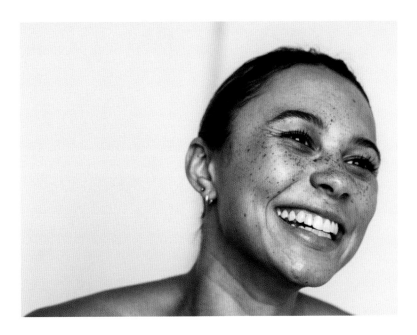

CONVERSATION

Before shooting Alex's portraits, I made sure we spent some time chatting before I even picked up a camera. Though it's not possible in every case, I ideally like to spend at least 15 minutes in light conversation before getting a subject in front of the camera. In fact, I bake it into the shoot schedule. It can be anything from the weather to work to current events; the actual topics of conversation aren't really that important. What you're really doing is breaking the ice. Chatting also helps you to get a sense of who your subject is and what their personality is like. It turned out that Alex had a very happy, friendly, and laid-back nature. It wasn't until we had an actual conversation that I realized I wanted her portraits to feel light, unstructured, and carefree—as she was—rather than the more classic studio portraits I had initially planned to shoot.

COLLABORATION

The single most important thing I do to build rapport is turn the whole thing into a collaborative process. Prior to the shoot with Alex, for example, I emailed her some reference images that reflected what I had in mind and asked if she had any ideas she wanted to throw into the mix. At the studio on the morning of the shoot, we went over the schedule to make sure we were on the same page. And throughout the actual shoot, I showed her some of the raw photographs I was taking and asked for feedback and suggestions. You can't do this with every subject or situation, of course; if it's a commissioned portrait for a client, you need to stick to the deliverables. But remaining open and flexible is key to good rapport.

COMPOSITION

I'm a strong believer that there are no hard-and-fast rules for photography. That said, if you look at some of the best portraits, chances are, they've probably applied one or two basic rules of composition. Like lighting, composition can dictate the feeling of a portrait and create an immediate connection with the viewer. Composition alone can make the difference between a flat and unremarkable portrait and one that's exciting and engaging. That said, feel free to use the following 'rules' as inspiration, rather than instruction.

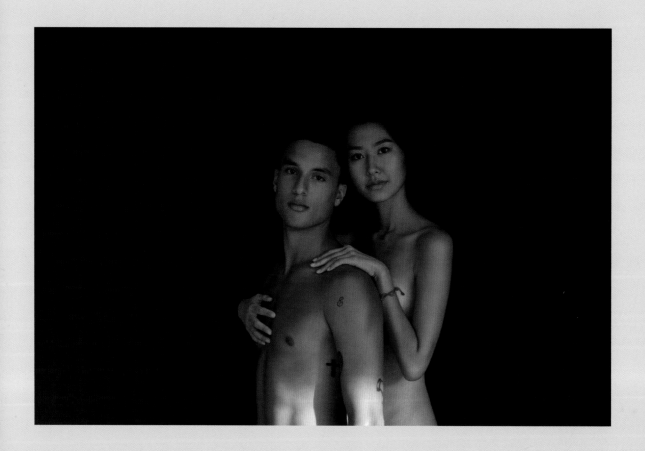

NEGATIVE SPACE

Negative space is the area surrounding the main subject that is left unoccupied. Usually, I like to have enough negative space in all my portraits to allow for some 'breathing room' around the subject. Generally, you'll want to aim for a nice balance of positive and negative space, but in the photograph opposite, I experimented with a heavier use of negative space, pulling all the way back to shoot my subjects from a distance. When you do this, there's always the risk of the subject(s) being swallowed up by too much negative space, but in this instance, I think it actually helps to draw the viewer's eye to them even more, while giving the portrait a clean, spacious, minimalistic feel.

RULE OF THIRDS

The rule of thirds is a classic rule of composition and one that I use often, whether I'm aware of it or not. It almost always makes for a more interesting-looking portrait. It's fairly simple: you mentally draw two horizontal and two vertical lines onto your frame, dividing it into thirds in both directions. To compose the image, place your subject along one of the points of intersection. In the photograph below, I followed the rule to the letter, positioning the subjects' faces along one of the vertical lines, which meant they appeared in the portrait slightly off-center. I also posed the subjects to lean and gaze into the line, which I thought looked more natural in this instance than if they were looking straight at the camera.

HOW I SHOT IT

I photographed Karen and Kevin as part of a fine art couples series entitled *Together*. All three portraits that appear here were shot in a top-floor studio, lit exclusively using natural light. I used black V-flats to add shadow detail in some areas and white reflector cards (angled on the floor before them) to soften shadows in others. I shot the entire series using a Leica SL with a 24–70mm lens.

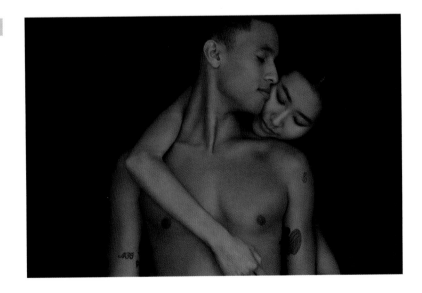

CENTERED SUBJECT

Contrary to the principle behind the rule of thirds, in some cases, having a centered subject is simply the best way to shoot a portrait. As much as I normally hate to center my subject, in the photograph below, I found that it made the most visual sense: it created balance and symmetry, anchored by my subject's features and collarbone, and gave the whole portrait a striking simplicity. If her partner had been in the shot, those elements would have been lost, and so the centered subject placement would not have been effective. But in this case, I think it made for the most compelling portrait.

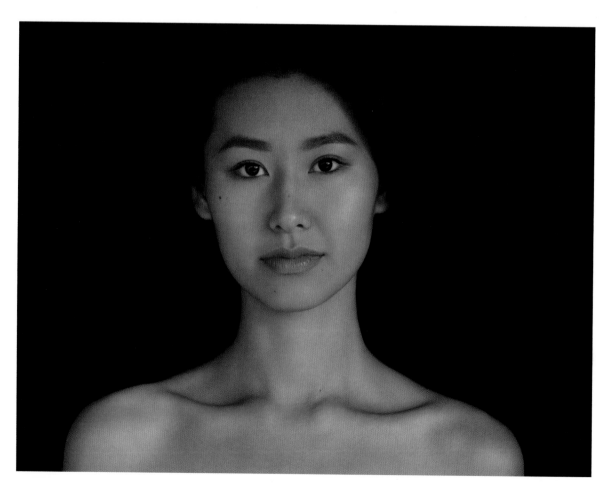

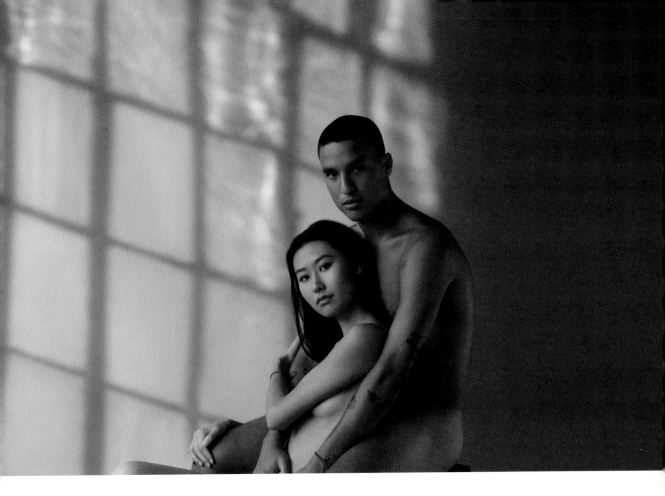

LEADING LINES

In portraiture, leading lines are lines that draw the viewer's eye towards the subject. These can be natural lines that already exist in the background or environment, such as railroad tracks or a horizon line, or lines that you create or manipulate. In the photograph above, I positioned my subjects next to a large floor-to-ceiling casement window and used shadows cast by the sunlight as leading lines.

STORYTELLING

I believe that storytelling is at the very core of portraiture. Every single person has a story, and the way they look and how they present themselves—whether they're aware of it or not—helps to tell that story. The color of someone's hair and skin, their laugh lines and wrinkles, their facial expressions, clothes, jewelry, or tattoos (or lack thereof) all give you a glimpse into who they are. If you photograph them in their own environment, that reveals another very powerful layer, too. When you take a portrait of someone, you are telling a part of their unique story.

You can tell a story about an individual in one single portrait, or you can tell their story in several images. The latter is what I did in this series of photographs I shot of the Hawaiian taro farmer, Ka'ai. I've shared in this section some things to consider when you're telling someone's story.

WHERE ARE THEY FROM?

An individual's environment, whether it's their home, place of work, or even just a place they like and feel comfortable in, is an essential part of who they are, so you should consider yourself lucky if you're able to shoot a subject on location. When speaking with Ka'ai, a taro farmer in a lush, secluded valley on Hawaii's Big Island, it was clear that the place where he lived and worked was intrinsic to who he was. In the photograph below, I wanted to capture his deep connection to the land by taking a wide shot of him in the taro fields and mountains behind his house. Going wide typically helps to establish a sense of place.

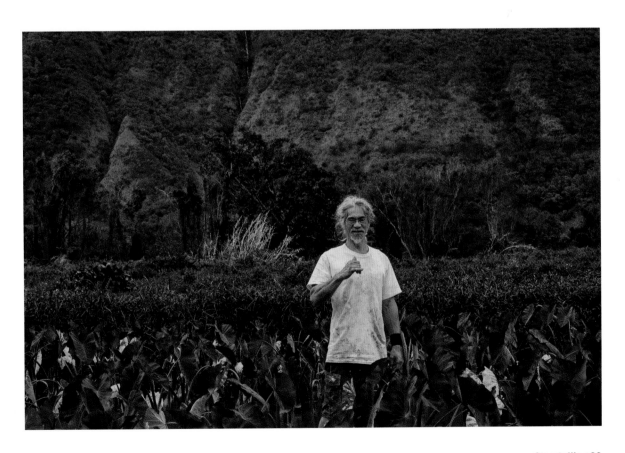

WHO ARE THEY?

At the beginning of a shoot, I like to mentally 'zoom out' and take in a person's entirety and essence, observing them as if from a distance and collecting 'surface' information like their age, ethnicity, and occupation. Then, often during conversation, I'll 'zoom in' to take in all the details that help define them. One of Ka'ai's most defining features, for example, was his hair: long, dreaded, messy, and silver, which told me he was a man of the earth who didn't fuss much over his appearance; it told me he was old and wise. I will say more about how to highlight details on page 116, but you'll want to keep an eye out for them from the beginning. Capturing even one single meaningful detail can be powerful and revealing.

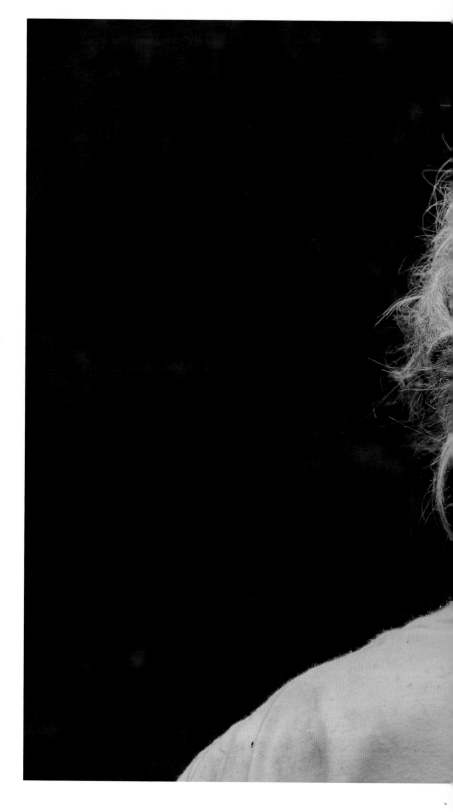

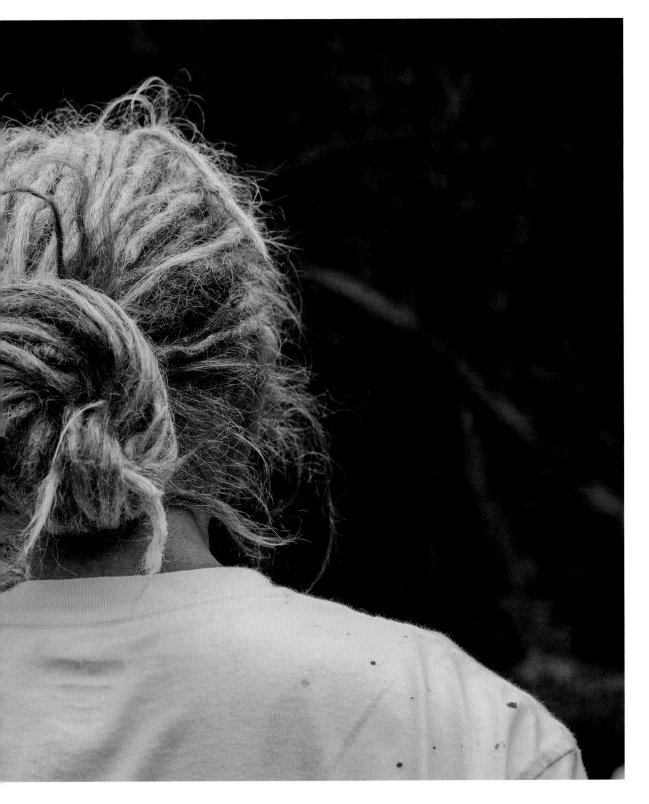

HOW I SHOT IT

I feel very lucky to have met Ka'ai completely by chance while shooting a travel magazine feature on Hawaii's Big Island. One of the tour operators I'd befriended had taken me down into a beautiful secluded valley to meet some locals, and Ka'ai was kind enough to spend the day with me and allow me to photograph him. I hadn't prepared at all to take portraits that day, but I was thankfully armed with my Nikon D800 and a 24–70mm lens, which is my go-to combination for travel photography and performs well in almost any situation. It happened to be overcast, which I find to be the perfect condition for outdoor portraits because the clouds soften the sunlight for an even, low-contrast light.

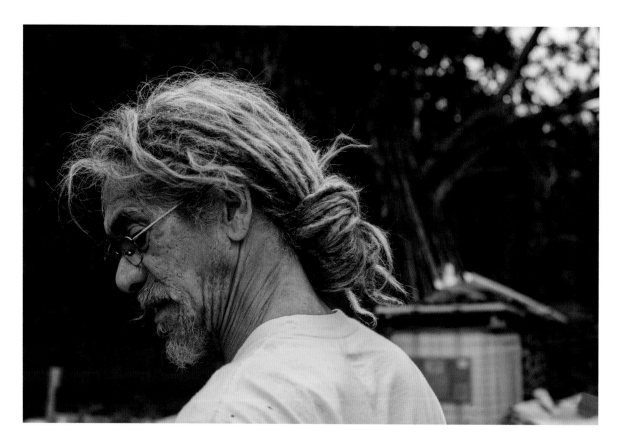

ANGLES AND PERSPECTIVES

Rather than trying to photograph someone as you encounter them, take a moment to study the scene for more original perspectives. For example, I wanted a portrait of Ka'ai in front of his home, but I knew that getting him to pose directly in front of it would feel contrived. Instead, I asked him to tend to the plants in his front garden as he normally would, and I documented him while he did so, shooting at a lower angle to get his house in the frame. The resulting portrait, featuring his profile in the foreground and subtly including his house in the background, comes across as far more truthful and compelling than if I had tried to pose him.

INTERACTION

Probably the greatest storytelling hack of all is to have your subject interact with something (or someone) in their environment. In the photograph below, I asked Ka'ai to go about doing everyday tasks, like harvesting taro or peeling sugarcane, and then photographed him as he worked. I love the rawness of the resulting photo: his expert wielding of the knife, his dirt-splattered clothes, his rough, calloused hands. It says a lot about him, even though you don't see his face.

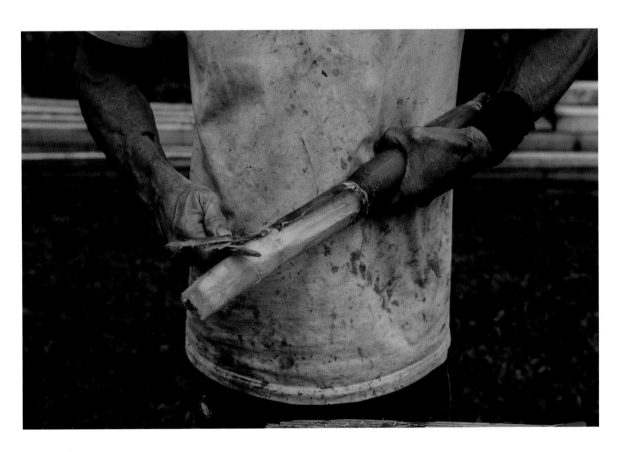

2

—

TYPES OF PORTRAITURE

STUDIO PORTRAITS
ENVIRONMENTAL PORTRAITS
FINE ART
BLACK AND WHITE
GROUP PORTRAITURE
BODIES
ACTION
PORTRAIT SERIES
DOCUMENTARY
EDITORIAL
COMMERCIAL
SPECIAL EVENTS
SELF-PORTRAITURE

When I think of portraiture, what immediately comes to mind is an individual photographed in a studio in front of a backdrop, masterfully illuminated with natural-looking artificial light. But that's just one kind of portrait—there's an entire world of portraiture out there, and you're not limited to any single type.

From studio portraits to environmental portraits, to nudes and black and white, there are endless styles and approaches to photographing people. In this chapter, I'll go over many of these different types of portraiture and will share with you how I shot my own images in each style. That said, I personally treat portraiture as a very fluid art form rather than a series of neat, well-defined categories. In your own journey, I encourage you to mix, match and experiment with any style that speaks to you.

Camera: Leica SL
Lens: 24–70mm
ISO: 320
F-stop: 5.6

These studio portraits were shot as part of a men's fashion magazine editorial featuring real-life couple Matthew and James. We shot in an industrial-style loft in Los Angeles that had huge floor-to-ceiling wraparound windows, so I lit the portraits using a mix of natural light and strobes, and I used black V-flats for negative fill (you'll find this is kind of my go-to formula for lighting any studio portrait).

Though it looks like I used a grey seamless backdrop, I actually used a white cyclorama (cyc) to add more depth to the portraits. Because the subjects were shot so far in front of the cyc—eight to ten feet—it fell largely into darkness, with varying degrees of grey depending on where the light fell. (You can see this best in the image opposite). I thought it would look more interesting, dynamic, and less flat than working with just a plain grey background, and it also helped draw out the different shades of grey in their outfits.

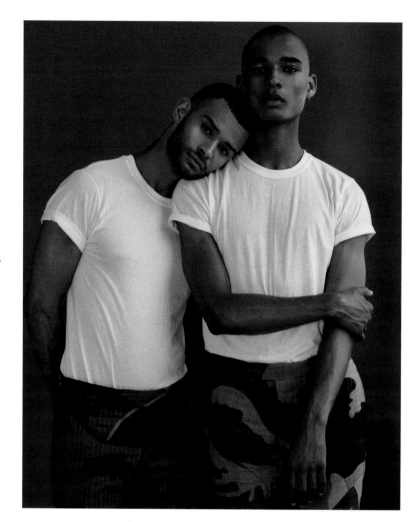

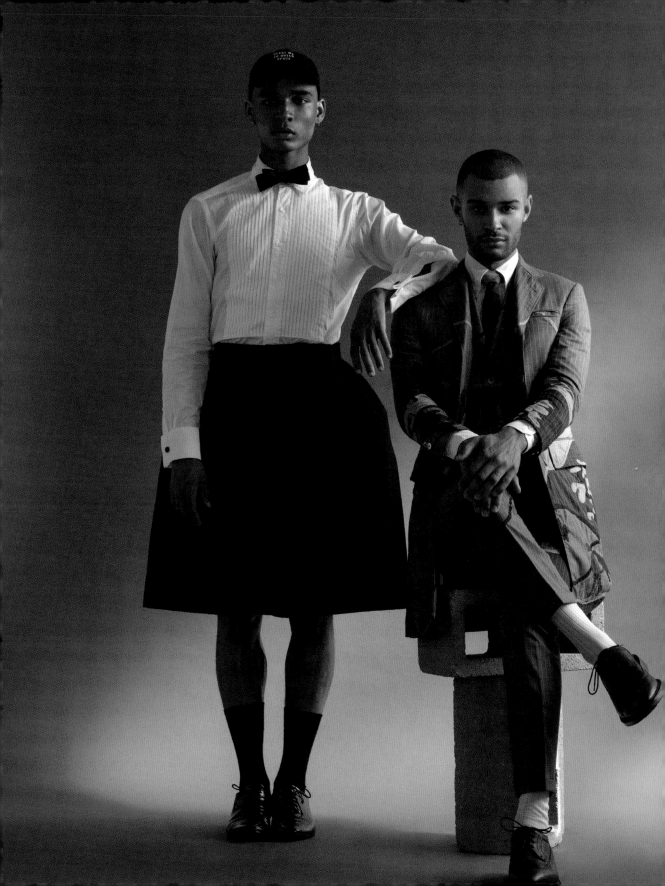

STUDIO PORTRAITS

Shooting a subject in a studio is the photographer's equivalent of an empty canvas, a blank slate, the opportunity to create something from nothing. Unlike with environmental portraiture, you aren't relying on an individual's surroundings to give context or tell their story, so it's almost entirely up to you to create meaning. For all its seeming simplicity, taking a great studio portrait involves a not-so-simple interplay of photographic skill, connection with your subject (see page 20), lighting know-how, composition sense, and a whole lot of trial and error.

A few years ago, inspired by the experiences and stories of my transgender friends and family members, I shot *Transparent*, a portrait series highlighting and celebrating the transgender community. Aesthetically, I wanted the portraits to be as clean and minimal as possible to allow each individual's essence to shine. (These photographs went on to be featured in *Harper's Bazaar* and by the designer Kenneth Cole on his blog.)

GET LIT

Beautiful lighting is crucial to any portrait, whether you're shooting in a studio, outdoors, or in your subject's environment. But being in a studio environment, you have the most control over your lighting situation, which is both awesome and challenging.

In the *Transparent* portraits, for example, I wanted soft light and open shadows on each subject's face—almost as if I had shot them outside on a slightly overcast day. I achieved this by using front-facing natural light with the subject directly in front of a large window, which gave their faces an even frontal fill. On either side, I boxed the subject in with black V-flats to create negative fill, subtracting some of the daylight and creating shadow detail on either side of the face. Additionally, I supplemented the daylight by bouncing strobe light off the white ceiling overhead. This served to add light from above that mimicked the daylight from the window, illuminating details in the subjects' hair, and making them 'pop' from the background. (For more on lighting techniques, see pages 16–17.)

EXPERIMENT

Beyond lighting, there are countless ways you can get creative and take your studio portraits to the next level. I like to build out backgrounds, even if it's as simple as using a grey or white seamless background and an apple box to sit my subject on, which tends to lend itself well to my clean, minimalist style of portraiture. Alternatively, you can design more of an elaborate set: you could paint or create a special backdrop, set up a couch, add props, drape the set with silk or fabric—it all depends on the kind of vibe and aesthetic you want to achieve.

Personally, I love to treat the studio as a location in and of itself, utilizing the bones of the space as a backdrop—look for lofted ceilings, exposed beams, windows, cycloramas, lights, or mirrors, for example. I just love the raw industrial look that this lends to portraits. I like to shoot through windows if they lead out onto a terrace, which adds unusual dimensions to an otherwise straightforward photograph and can make a portrait appear more emotional or abstract. If there are mirrors, try shooting the subject via their reflection, which can add interesting layers.

HOW I SHOT IT

I shot the following portraits at a New York studio with a Nikon D3X using an 85mm prime lens. I used natural light from a front-facing window, paired with supplemental strobe lighting that I bounced off the ceiling to illuminate each subject's hair and make them 'pop' a little more from the background.

Though it looks like I shot Garnet against a black wall or backdrop, I actually shot her inside the crease of an open black V-flat. Rather than setting up a separate background and placing black V-flats on either side of the subject, this is a hack I often use to cut down on the amount of equipment I'm using while still creating perfect negative fill and shadow detail on either side of my subject's face. This trick works especially well if you're shooting a tight portrait, like this one, where the background features very minimally.

I purposely shot Garnet at an angle to illuminate her incredible cheekbones and bone structure. If your subject has sharp, bold features—as Garnet does—shooting their face at a slight angle will almost always look better than shooting them front-on.

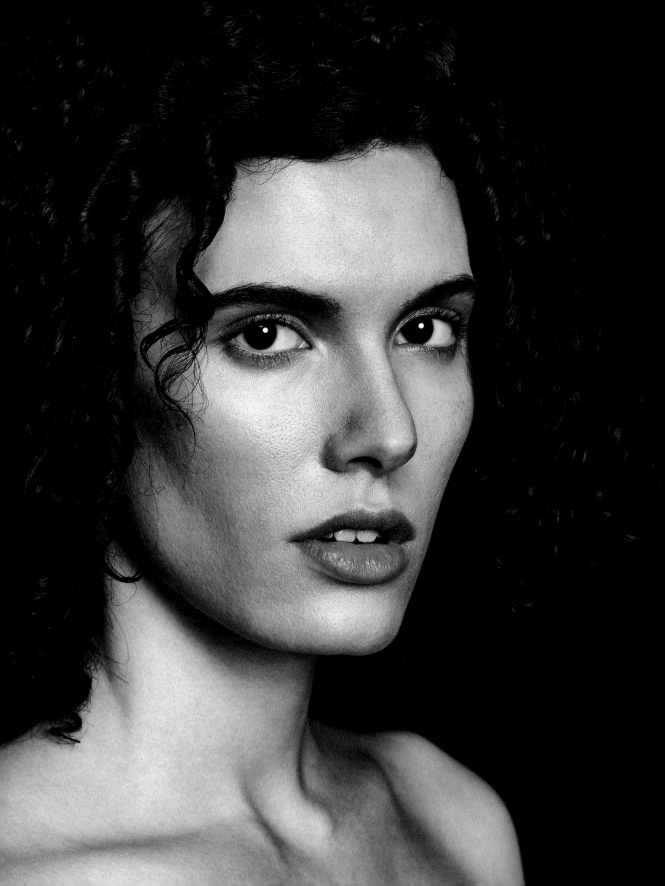

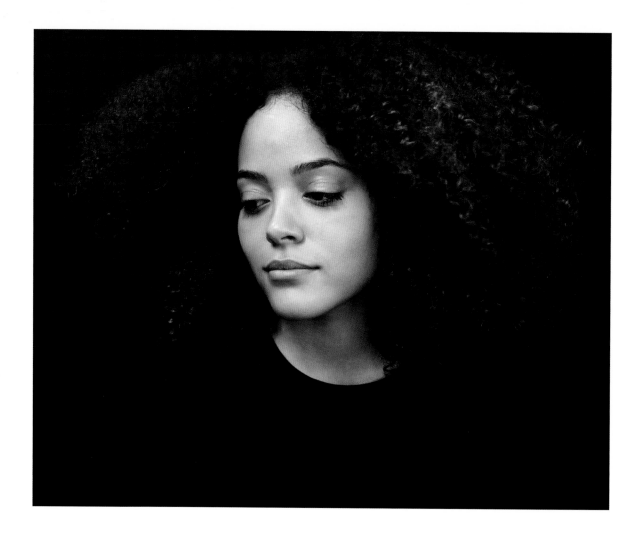

Camera: Nikon D3X
Lens: 85mm prime
ISO: 400
F-stop: 5.6

As with Garnet, I shot Quintessa inside the crease of an open black V-flat. This created instant negative fill and shadow on either side of her face. Quintessa, like Garnet, had striking bone structure and strong cheekbones, so though I shot her front-on, I had her angle her face slightly towards camera left to draw out these features.

Soft, overhead strobe lighting is especially important in a shot like this, because almost all the elements of the portrait are dark, from the background to the subject's hair, to her shirt. The overhead lighting, acting like sunshine coming softly from above, helped to bring out the detail from even the darkest parts of the image—the texture of her hair, for example, and the creases in her shirt—and added separation between all these elements. Without soft, supplemental overhead light, you'd get a floating head scenario, which is not flattering!

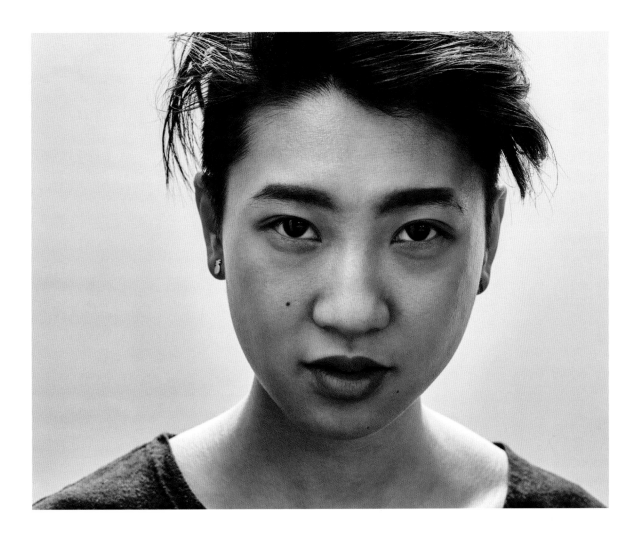

Camera: Nikon D3X
Lens: 85mm prime
ISO: 400
F-stop: 5.6

For this portrait of Jes, I went for the opposite effect I used for Garnet and Quintessa, flipping the V-flat to its white side for her background. As a result, the portrait itself was much lighter and brighter by default, and I had to bring in some additional negative fill using black flags on either side. (I did this purely for aesthetics as I didn't want the entire portrait to be shot against black).

I also positioned Jes so that the overhead light was not from directly above, but slightly behind her, so that she appeared subtly backlit (you can see the effects of this in the highlights on her shoulders and strands of her hair). This helped to add further depth and separation between the subject and background, which is just as important when your image skews high-key (lots of bright, light tones) as low-key (more shadows and dark tones). No matter what the mood or effect I'm after, I always strive to have a balance of light and shadow.

ENVIRONMENTAL PORTRAITS

Unlike in studio portraiture, environmental portraits are typically taken in an individual's natural environment—a place where they live, work, res,t or play—with the intention of capturing them within a specific context. This can be a powerful way to tell someone's story. One of the main reasons I love shooting environmental portraits is because they can reveal so much about a subject: it's an excellent way to show who they are, what they value, and how they live.

You don't have to limit yourself to a subject's home, workplace, or regular haunts, however. Environmental portraits can be taken in an environment of your (or the subject's) choosing, perhaps just because it's beautiful or interesting. Even in this case, I've found that subjects are generally more comfortable and relaxed than they are in a studio setting; and a relaxed subject just makes things easier for me as a photographer.

OBSERVE

I always find that I get more natural-looking environmental shots if I start off by hanging back and letting the subject interact organically with their surroundings, simply documenting them rather than trying to pose or frame them straight off the bat. Breanna, an actress and model who lived in Los Angeles, loved the ocean and moved comfortably and easily around the beach in Malibu, where we shot. I encouraged her to simply do what she would do at the beach if I wasn't there—walk along the shore, wade in the waves, look for seashells, whatever felt natural—for 15 or 20 minutes. Of course, some subjects will need more specific direction, but generally, if the person is in a familiar environment, they'll interact naturally with it, and that will translate to better portraits.

ENGAGE

After spending some time allowing my subject to interact with their surroundings, I always find I have a slightly better understanding of who that person is, how they move, and therefore the kind of portraits that will work best. This is when I begin to engage, asking the subject to pose and interact with the camera, communicating to them the specific shots I want to take, giving them cues and feedback. Make sure you stay present and feel it out—some subjects move better when given much looser direction, as Breanna did, while others require more precise instruction.

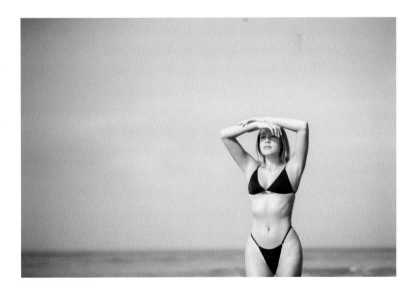

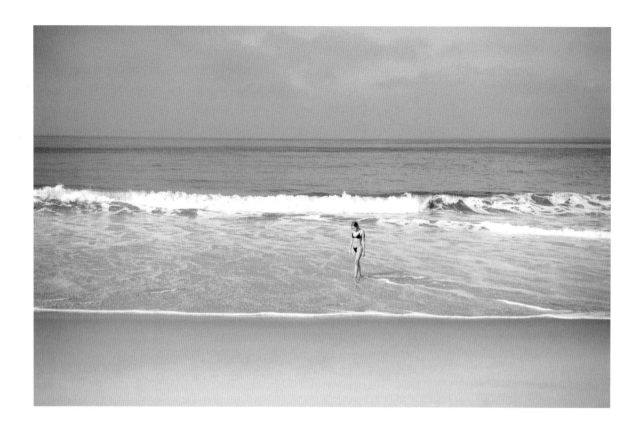

HOW I SHOT IT

I photographed Breanna using a Nikon D850 with a 50mm prime lens for the wide shots and an 85mm lens for tighter shots. It was a cloudy day and I relied on natural light, which I always prefer for environmental portraits. Soft, flat, overcast light will blanket your subject rather than illuminate specific areas; it won't cast harsh shadows on your subject's face like bright sunshine will. Of course, one of the constraints of shooting an environmental portrait is your lack of control over the lighting, and perfect lighting conditions are rare.

GO WIDE

There are so many ways of shooting an individual in their environment, but my favorite is the wide shot, one that captures their entire environment and establishes a very clear sense of place. In the photo above, I wanted to capture Breanna in her element, as well as highlight the sheer scale of the ocean behind her. To do this, I backed up significantly and used a standard 50mm prime lens. (I didn't want to use *too* wide a lens because I didn't want to lose her altogether.) In the resulting portrait, Breanna actually appears slightly blurred while the ocean is clear and crisp, which offers a nice contrast to the next portrait, where the focus is flipped.

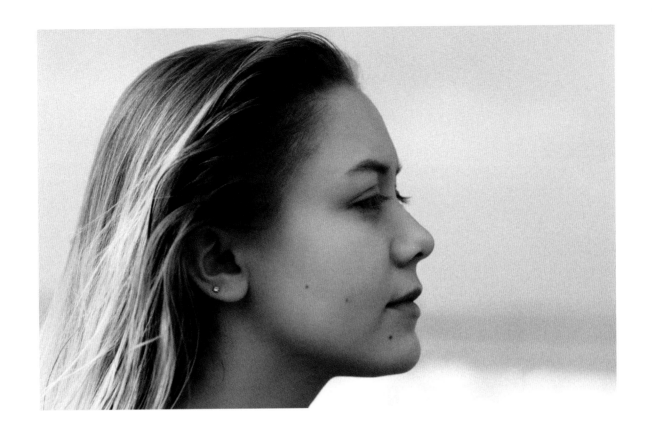

GO TIGHT

Shooting your subject up close imparts an intimate feel to an environmental portrait while maintaining a subtle sense of place. In the shot above, I wanted to focus more on Breanna's profile and features, keeping the details of her face and hair crisp, without losing the ocean as an element of the portrait. I used an 85mm prime lens to compress everything a bit and a shallow depth of field (f/2.8) to keep the focus on Breanna.

PRO TIP

When shooting environmental portraits, it's important to always keep an eye out for personal details such as cool tattoos or piercings, rips in jeans, or paint splatters on a shirt as well as environmental details like belongings spilling out from your subject's beach bag, a faded pair of favourite sneakers, flip flops in the sand, or their beat-up old Jeep. These details tell a story about who the person is and can contribute to a compelling series.

FINE ART

Though there isn't a clear-cut definition of what fine-art photography is exactly, the general principle that distinguishes it from other types of photography is its purpose: a fine-art photograph is less concerned with recording or documenting a subject and more about making a statement. Much like a painting, an artist uses a fine-art photograph to say something, whether it's a story, emotion, idea, or opinion. It often tends to be more abstract than literal to get the viewer thinking about the meaning, often warranting an artist statement, like the ones you might see beside artworks in a museum. In short, a fine-art photograph is one that you can easily visualize hanging on a wall or in a gallery.

What I love most about fine-art portraiture is the freedom it gives you as an artist. In traditional portraiture, the aim is to capture the subject as honestly and authentically as possible. In fine-art portraiture, this isn't as important—instead, the artist's vision is absolute. More creative liberties are allowed; the artist is free to unload and project their own ideas, biases, and perspectives onto the subject. I often liken traditional portraiture to a news article, whereas fine-art portraiture is more like a poem or a personal essay. Ultimately, the final portrait tends to be more revelatory about the artist than the subject.

PURPOSE

So long as you have a person as your subject, a fine-art portrait can look like anything. (See, for example, the work of Diane Arbus versus Herb Ritts mentioned on page 53). But, as I've said, one of the main things that differentiates fine art from a regular portrait is its purpose. The portrait doesn't have to be literal; in fact, many fine-art portraits are not. It doesn't even need to have a face in it. What's more important are the following questions: How you want people to feel? Do you want your art to evoke joy, sadness, mystery, wonder? Are you trying to inspire your viewer, warn them, provoke nostalgia, or remind them of something? Is it a political statement, a reflection of your values?

When I shot *Bodyscape*, below, I wanted to embody the oneness of humanity and nature. Through the human form, I wanted the viewer to be reminded of a landscape: valleys and hills and peaks, light and shadows, textures and gradients, soft and sharp. I wanted the negative space to be reminiscent of a night sky beyond the distant horizon and the curves of the body to mirror the contours of a moonlit landscape. I wanted to show how the beauty and complexity of a landscape could be reflected in a single human body.

PRO TIP

If you're thinking of shooting fine-art nudes, hire a fine-art nude model. These are professionals who have great body awareness. They pose for this kind of portraiture for a living and respond well to instruction, which makes creating good photographs just that much easier.

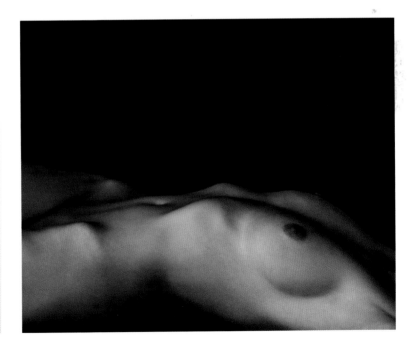

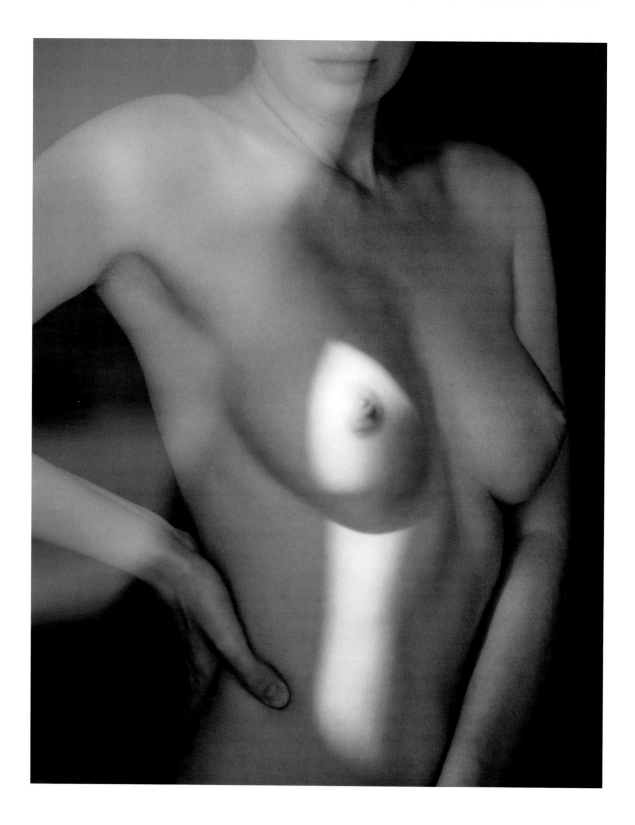

HOW I SHOT IT

This shot and the one on the previous page were both shot with a Leica M10 and a 50mm prime lens. *Bodyscape* was shot on a black seamless paper background and side-lit using exclusively natural light from a bank of windows on the right. *Irena Through Glass* was also shot on black seamless paper, however the set was repositioned so that Irena was partially in diffused light and partially in direct light. I took the shot through a window. Something I've noticed about every fine-art shoot is that the vision in my mind almost never translates perfectly when I'm on set, so it's important to stay open and not married to a specific idea. Stay present and aware, and let the subject and the lighting breathe their own life into your vision.

PLAY

There's probably no kind of portraiture that allows you more creative flexibility than fine art. Here, you have complete creative control, from the location and the lighting to the composition and color. Depending on your purpose and vision, you can get abstract, go black and white, use props, shoot nude, or play with different effects.

In *Irena Through Glass*, left, I wanted to fuse the eroticism of classic Renaissance nudes with the creativity and surrealism of Irving Penn, one of my favorite portrait photographers. In Penn's *Girl Behind Bottle, New York* (1949), he photographed a woman smoking a cigarette positioned elegantly on the other side of a half-empty wine bottle. I wanted to borrow this idea—to create some softness, depth, and mystery—by photographing Irena through a window. I always like to balance the elements of light and dark, so I angled Irena in such a way that a single beam of light hit her chest and torso, giving the otherwise dark image a central focal point while adding layers to the frame.

PRO TIP

I talk about the importance of studying the masters on page 150, but I wanted to include here some of my favorite fine-art portraits. By studying these images, you'll be able to appreciate just how diverse fine-art portraiture can be. Diane Arbus's documentary and street-style portraits, for example, are as thought-provoking as, say, Yousuf Karsh's more stylized and polished studio portraiture. And yet, each of them has a certain, special, undeniable quality that elevates the image from just a regular portrait to a piece of art.

- Irving Penn: *Salvador Dali* (1947), *Girl Behind Bottle* (1949–50), *Nude No. 58* (1949), *Irving Penn: In A Cracked Mirror (Self-Portrait) (A)* (1986)
- Yousuf Karsh: *Audrey Hepburn* (1956), *Christian Dior* (1954), *Martha Graham* (1948), *Albert Einstein* (1948), *Solange* (1935)
- Diane Arbus: *Identical Twins* (1967), *Lady bartender at home with a souvenir dog* (1964), *Young man in curlers at home on West 20th Street* (1966), *A naked man being a woman* (1968)
- Herb Ritts: *Versace Dress, Back View* (1990), *Tatjana Veiled Head* (1988), *Versace, Veiled Dress* (1990), *Christy Turlington* (1988), *Wrapped Torso* (1989), *Naomi Campbell* (1985), *Elizabeth Taylor* (1997)

BLACK
AND
WHITE

One glance through my body of work and it's pretty clear
that black and white is my preferred style of photography.
I love shooting in black and white for many reasons. For one,
removing color helps eliminate distractions and refines an
image by stripping it down to its base elements of texture,
light, shape, and form. Without color, you're also left to play
with tonal range and contrast, which trains you to see images
with completely different eyes. Plus, it looks timeless
and classic!

Portraiture, in my opinion, is one of the best uses of black-and-
white photography. It may sound counterintuitive, but I think
that stripping color from a portrait actually allows you to see
an individual more clearly, revealing light and shadows in the
scene as well as the lines and textures of an individual's face,
in a way that color portraits can't. I also love the clean, pure,
minimalist aesthetic black and white imparts a portrait, which
lends itself particularly well to my own style of portraiture.

METHODS

There are several ways to create a black-and-white portrait. The traditional method, of course, is to shoot using black-and-white film. Alternatively, most DSLR cameras include a black-and-white (or monochrome, or greyscale) mode. There are also digital cameras that shoot specifically in black and white, such as the Leica M Monochrom, which have special sensors engineered to capture a wider tonal range. Using either of the latter two methods would allow you to view your black-and-white shots in real time.

The most common way, however, to create a black-and-white portrait is to shoot in color as you would normally on a DSLR, and then apply a black-and-white filter in post-production. Digital photography processing (via programs like Capture One, Lightroo,m and Photoshop) has evolved to the point where it's practically impossible for the naked eye to tell whether an image was filtered in post-production or shot on a classic SLR camera using black-and-white film.

MOTIVATIONS

I mentioned earlier that stripping color from a portrait can allow you to see the details of an individual's face more clearly. But that doesn't necessarily mean that all portraiture will look best in black and white. Take, for example, Steve McCurry's *Afghan Girl* (1984). The famous portrait of 12-year-old refugee Sharbat Gula doesn't display a lot of tonal range or remarkable detail, but it doesn't need to: what makes it such a powerful and unforgettable image is her striking green eyes.

Before shooting black and white, it's important to ask yourself whether color plays an important role in your portrait. Does your subject have any defining features—bright blue eyes or flaming red hair, for example—that would be best captured in color? Even an interesting interplay of colors in the overall image might make it worth retaining the color. In *Afghan Girl*, for example, Gula wears a deep red headscarf that works as a beautiful contrast to her eyes. Because the portrait is so color-driven, omitting the color would have taken away the very thing that made it so special.

Conversely, in the portrait opposite, I didn't feel that color would add anything significant to the overall image. In fact, I thought the clashing colors of her shirt were distracting, and I wanted to keep the focus on the contrast of her jet-black hair and pale skin. In the original Raw color files, the natural reddish-orange undertones in her complexion only took away from the cleanness and simplicity I was after, and so I felt confident that I could get rid of the color altogether.

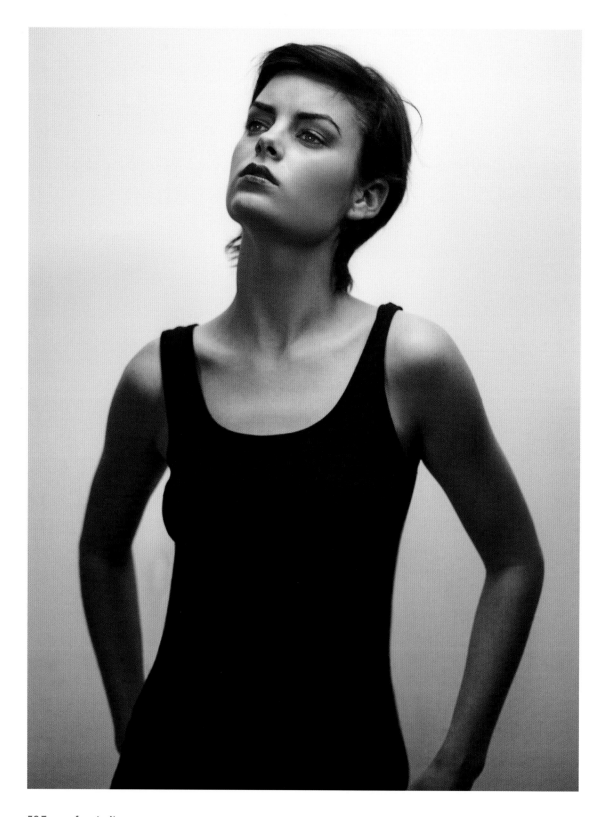

LIGHT AND SHADOW

When your image is stripped of color, light, shadow, and contrast become the stars of the show. In the portrait opposite, I placed a black V-flat to the right of the subject (camera left). My goals were to subtract light, adding shadow detail and contrast to one side of her face. On the other hand, if I wanted positive fill to make her skin appear more even and uniform, I'd flip the V-flat around to its white side—adding rather than subtracting light. Black-and-white photography is an excellent opportunity to play around with these subtleties.

TONE

Back in the 1930s, when everything was still shot on black-and-white film, the landscape photographer Ansel Adams created The Zone System, a technique that allowed him to perfectly control the contrast in his black-and-white photography. Its core principle was to 'expose for the shadows and develop for the highlights'. By exposing for the shadows in his scenery, he eliminated pure black from the photo and always retained detail, even in the darkest parts of his image. Similarly, his highlights were never blown out, and he typically kept a full spectrum of greys. In short: his images were tonally perfect. These detailed shadows and highlights, and a nice spectrum of grey, is typically what you want to strive for in a black-and-white portrait.

HOW I SHOT IT

I shot the portraits in this section as part of a magazine fashion editorial, using a Hasselblad 501CM and a 150mm lens. I personally find that medium-format film cameras capture a great deal of detail and a broad tonal range, which makes them ideal for black-and-white photography. In addition to using negative fill and slightly underexposing an image, if you are using a digital approach, you can also use channel mixers within your editing software's black-and-white filter to bring out more tonal detail and texture.

GROUP PORTRAITURE

Personally, I find shooting group portraits—whether for a wedding, an event, a magazine editorial, or even family photos —to be the ultimate challenge. It's one thing to build rapport with a single individual, but throwing multiple personalities into the mix makes for a different experience entirely. That said, there are a few ways you can make your group photos look natural, effortless, and striking.

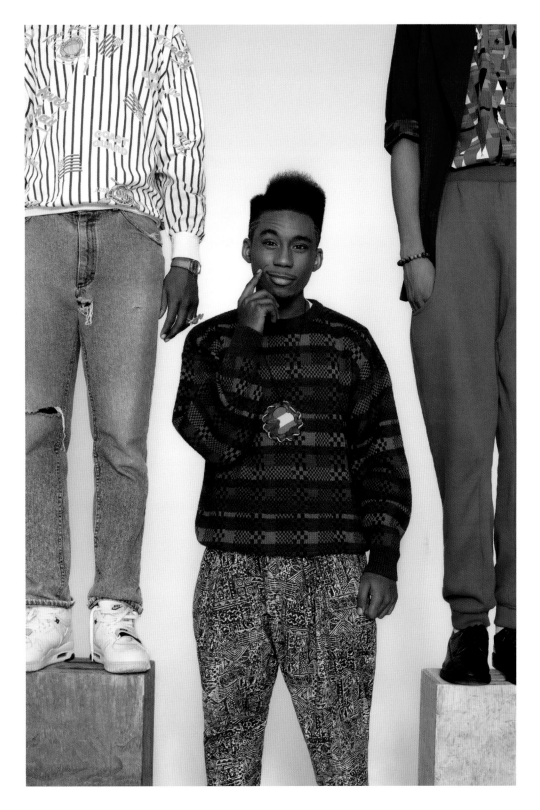

HOW I SHOT IT

This 90s Kid 'n Play-inspired fashion editorial was shot in a studio in New York using studio lighting. I wanted to replicate daylight without being at the mercy of actual daylight—group shoots tend to take longer than individual portraits—so I aimed hot lights at bounce cards placed directly in front of and slightly above the subjects. This gave off a soft, even, frontal top light. Additionally, I used black V-flats on either side of the subjects to enhance shadow detail.

These portraits were shot using a Canon 5D Mark II with a 50mm prime lens, which I find to be a great camera-and-lens combination when shooting handheld at lower shutter speeds. The stabilization in the camera and lens gives virtually no camera shake when shooting at 1/60 and f/8. Typically, in a studio, I like to shoot using continuous light and slower shutter speeds, which makes for a more natural-looking portrait.

PREPARE

It's a given that every portrait shoot requires preparation, but this is especially true for a group; you do not want to be fumbling and frazzled in front of a group of people, trust me. At the bare minimum, you'll need a wide-angle lens and a tripod for stability. If you're shooting at an outdoor location, you'll also want to visit the day before to scope out when and where the best light hits. And I always create a mood board beforehand (see page 142), which helps me clarify my vision and goals.

KEEP IT CLEAN

With so many faces and bodies in one photo, you'll want your background to be as minimal as possible. This is easy in a studio, but it can be difficult when you're on location. If you can't find a background that's not busy or distracting, see if you can position your subjects so the background looks distant or hazy, or open your aperture to play with a shallow depth of field.

SHOOT MULTIPLE SHOTS

I find it near impossible to get the perfect shot of everybody, but to improve my chances, I switch my camera to continuous shooting mode and shoot in short bursts, rather than one shot at a time. The first shot is usually no good, but the one or two directly after it are always better. Sometimes it takes dozens to get The One.

COLLABORATE

Unlike with one-on-one portraiture, it's harder to connect with multiple individuals at once, but it can be done. Before every shot, I like to communicate my goals to the group by telling everybody what I'm trying to achieve, and then be clear on what I need everybody to do. Involving them in the process of creation and making it a collaboration, rather than having them just stand there idly while I shoot, makes everyone feel more comfortable and relaxed, which results in more natural portraits.

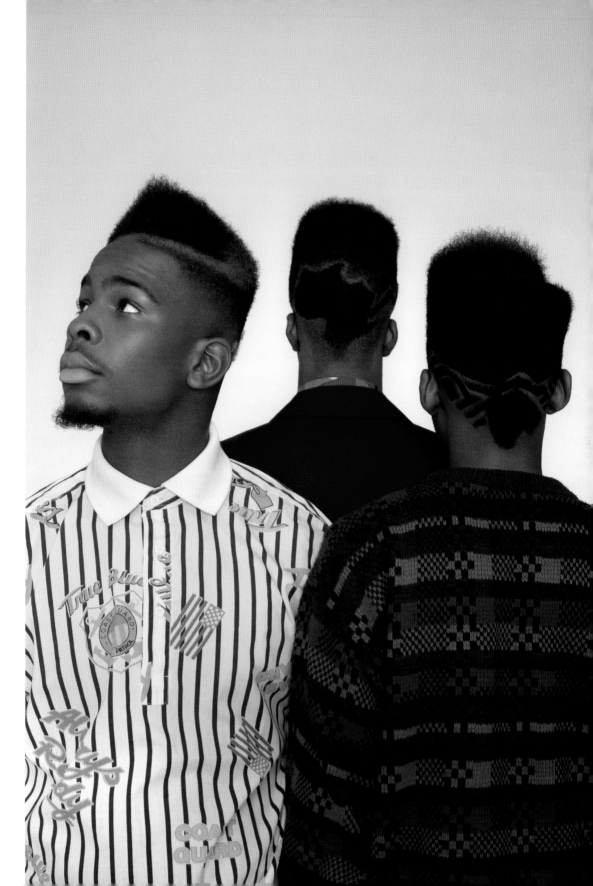

BODIES

I think the human body is the most beautiful thing on earth to photograph. The human form is so strong and fierce and literally life-giving, and yet when stripped down, it can appear vulnerable, soft, and delicate. Depending on how it's portrayed, it can be a symbol of pride or shame, power or submission. I explored this in my *Ageless Beauty* portrait series (see page 77), and it's something I'm continually drawn to return to.

Portraits that are body-focused do not necessarily have to be nude, but I do think nudity can powerfully express an idea, emotion, or statement. Unfortunately, in Western culture today, the naked form (particularly of the female) is overly sexualized and seen as shameful, though this is not the case in many other cultures. As photographers and artists, I believe we should not be afraid to portray the naked human form. Personally, I like to look at the human body in an abstract sense, in terms of curves, lines, and shapes.

SUBJECTS

It goes without saying that not every subject is best captured with nude or body-centric portraiture. The subjects I am currently most interested in shooting body-centric portraits of are dancers, athletes, pregnant women, bodies of color, and couples. Shooting a body-centric portrait—nude or otherwise—is most effective when the subject has a good command over their body and perhaps possesses interesting curves, forms, and colors that can be drawn out using the techniques on pages 120–5.

POSES

Because individuals know their own bodies best, I find it's most effective if you allow your subject to move freely rather than try to dictate specific poses or looks that you have in mind. For nudes in particular, I go with a 'controlled candid' philosophy, offering guidance rather than instruction. If there is one posing rule I stick to, it's that bodies usually look more flattering at a slight angle, rather than shot front-on. And unless your subject is a dancer or professional fine-art model, it also helps to have them sitting on or leaning against a surface.

LIGHTING

Light is the driving force behind all photography, but it's really everything when you're photographing bodies. Using studio or natural lighting, you can sculpt the body with light, creating emphasis and form. I personally recommend soft, natural light, preferably from a window in the late afternoon. Side light in particular can create beautiful highlights and shadows. On the other hand, low-key lighting using directional studio lights can create stunning, high-contrast bodyscapes.

CONSENT

Due to the sensitive nature of nude portraiture, it is essential that you obtain a subject's clear verbal and written consent to be photographed. A model release outlining the model's consent and specifying what you're allowed to publish, how the pictures will be used, and what the model will receive in terms of payment is necessary for all portraiture, but especially in the case of nude photography.

I recommend working with professional fine-art nude models, for whom all this is standard procedure. But if the subject is not a professional model or is new to nude portraiture, I suggest that they bring a friend or partner if it helps to make them feel safe and comfortable, particularly if we are shooting otherwise alone in a studio or on location. For these types of shoots, I usually err on the side of being overly communicative before, during, and after the shoot. There is nothing more important than making your subject feel safe and respected.

HOW I SHOT IT

I photographed Rosa as part of a Renaissance-inspired series in Sydney, Australia. I posed her against a hand-painted grey backdrop, next to a window where natural afternoon light streamed in. Being completely side-lit, half of her body remained shrouded in shadow, which made the image feel moody and added depth that would not exist if she were evenly lit all around.

This portrait was shot using a Leica SL with a 24–90mm zoom lens, which I find captures subtle details beautifully. I also prefer shooting body-centric portraiture with this camera, as it's completely silent and therefore less obtrusive, generally making the subject feel more comfortable.

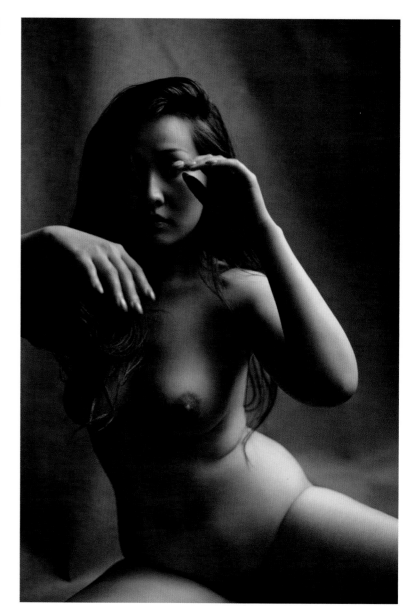

HOW I SHOT IT

I shot Erica in a studio in Los Angeles with large, slatted windows that cast interesting light patterns into the space. Instead of trying to mask them, I had her face the incoming light directly so that they played against her body, creating unusual highlights. I set up a V-flat to her right to add shadow. This portrait was shot using a Leica SL with a 24–90mm zoom lens.

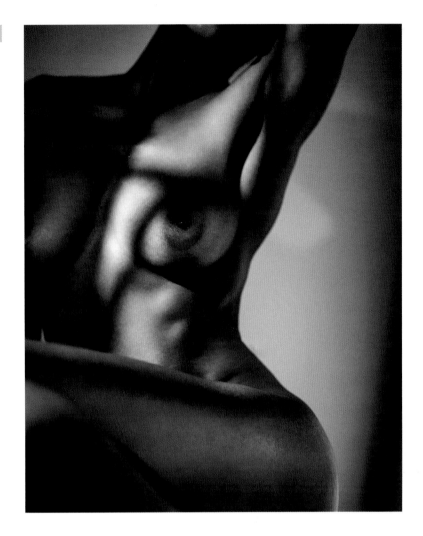

ACTION

When you think of action photography, or specifically action portraits, what probably first comes to mind is an athlete running or jumping, or a dancer suspended in mid-air. While these are indeed classic examples of action portraiture, I believe that the basic principle of this genre—photographing an individual in motion—can be applied to almost every kind of portraiture.

I like to think of action as less of a genre and more of a technique to add life and energy to a portrait. Photographing an individual in motion often makes them appear more natural, and the photograph more dynamic. Action photography also lends itself beautifully to portraits of kids, groups and families, although I often use it as a technique for traditional portraiture as well.

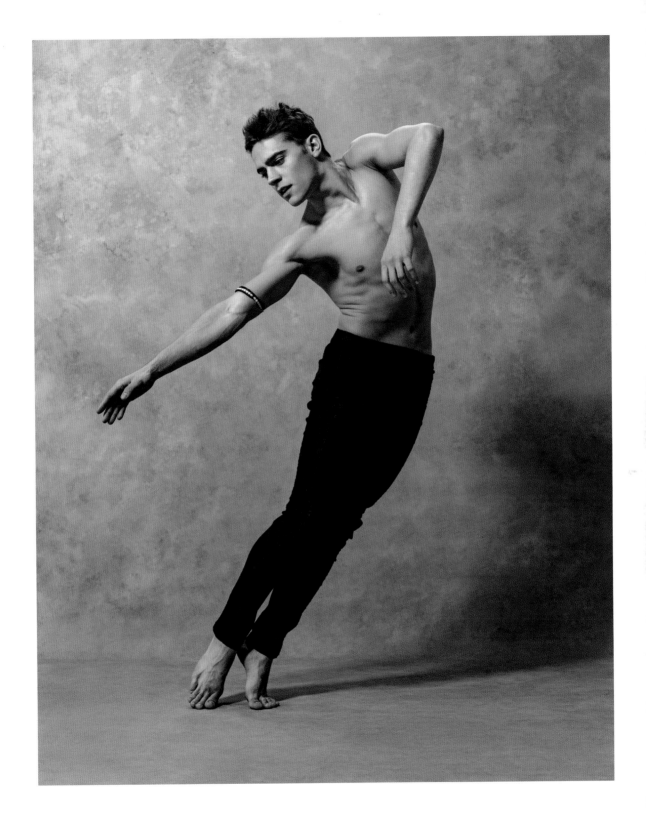

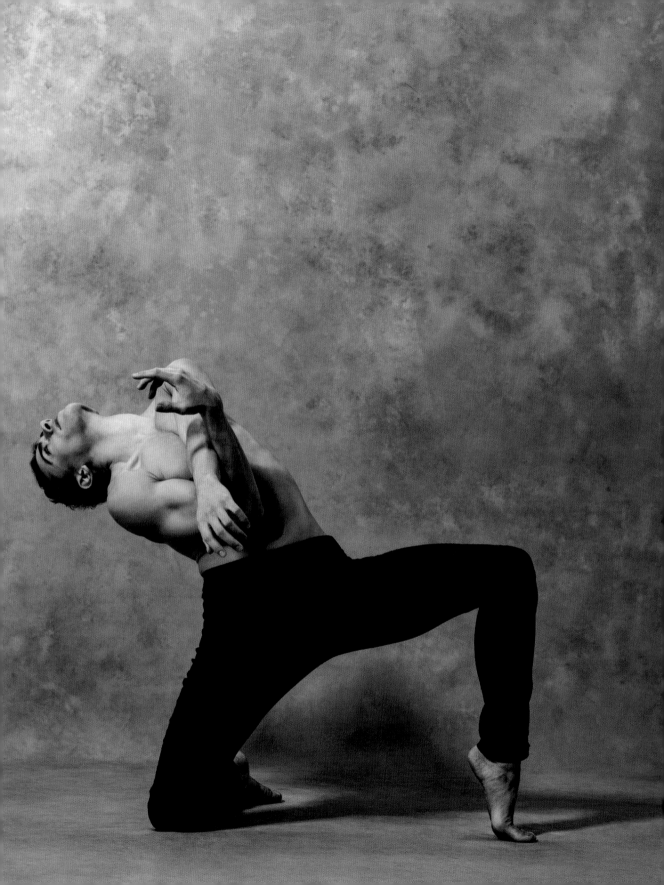

SHOOT IN BURSTS

Like when I photograph groups (see page 60), I switch my camera to continuous shooting mode and shoot in short bursts, which helps to capture even the most minuscule of movements. To freeze action in daylight without flash, you'll need a shutter speed of at least 1/500. As a rule, the faster your subject is moving, the faster your shutter speed needs to be. In the case of portraiture, however, you won't need to go higher than 1/500 unless your subject is moving extremely fast. In lower lighting situations, you'll need an on-camera flash or a studio strobe to freeze action.

USE A TRIPOD

There are some situations when you'll need a tripod for stability: if you're shooting from one spot with the action unfolding directly in front of you, for example, or if your subject is moving against a backdrop in a studio setting, as seen in the images in this section. I also find that using a tripod allows me to concentrate on capturing the action. When I mount my camera on my trusty Gitzo and pre-focus, all that's left for me to do is watch the action unfold and shoot.

SMALL AND SUBTLE

I was commissioned to shoot this series of Alvin Ailey American Dance Theater dancer Michael, and, being a professional dancer, his movements are smooth, graceful, and polished, making the overall portraits feel alive and fluid. But you don't need to shoot a dancer in motion to infuse this same sense of aliveness and movement to a portrait. Even when you're shooting a traditional portrait of a regular subject, having them engage in some small, everyday movements while you shoot—flipping their hair, walking a few steps, buttoning their coat, or even interacting with a prop—can add some energy and vitality into a portrait. This technique lends itself particularly well to documentary portraiture (see page 84) and environmental portraiture (page 46), where having a subject interact with their surroundings can help to tell their story.

HOW I SHOT IT

I photographed Michael at a studio in New York using a combination of natural daylight streaming in from camera left and a strobe positioned in the same direction. Using a light meter, I matched the strobe's intensity with the daylight exposure to partially bathe the subject in bright, soft lighting in order to capture sharp, focused action shots. This lighting setup also allowed me to catch Michael's shadow on the ground beneath him; I like action portraits to have a nice mixture of light and shadow.

I shot these portraits using a Hasselblad 501CM with a Phase One digital back and an 80mm prime lens. Though Hasselblad is not typically known for being an action camera—it's very manual and doesn't have a continuous shooting mode—I liked that it didn't restrict the sync speed of the flash, which allowed me to blend the strobe and daylight seamlessly, making the images appear softly and effortlessly lit. The Phase One back also captures incredible detail and sharpness, which is important when shooting a subject in motion.

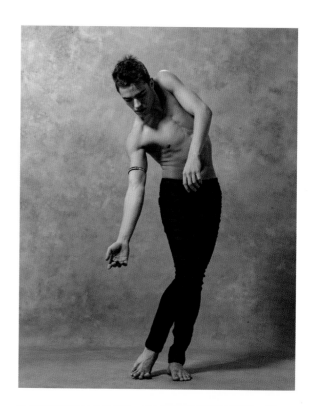

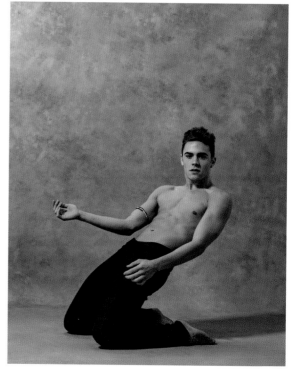

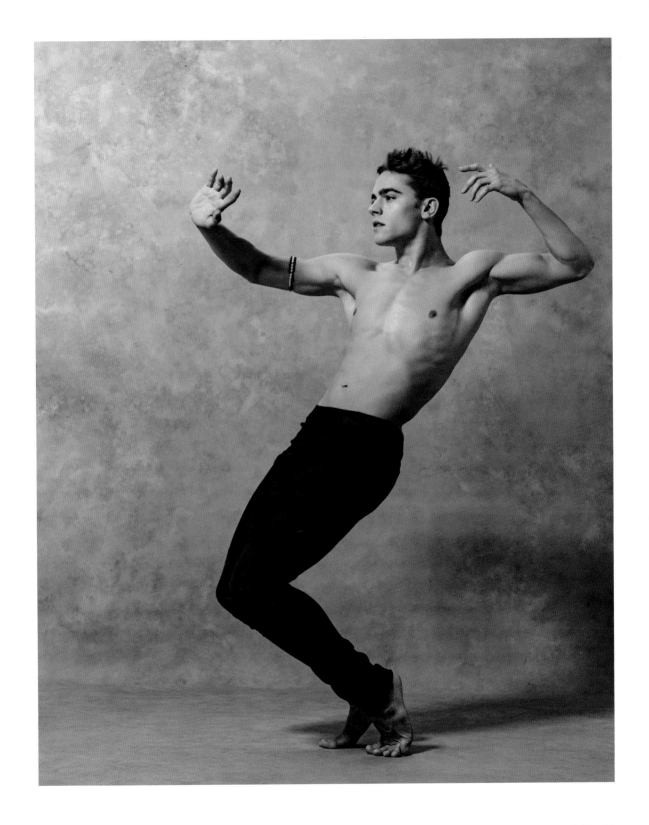

PORTRAIT SERIES

A portrait series usually contains three or more portraits, typically connected by a theme or story. They can be of the same subject or multiple subjects; they can be abstract and entirely fictional—an absolute creation of the photographer's imagination—or a raw, documentary-style depiction of real life.

The power of shooting a portrait series is that you can go deeper, to say more. It's easier to tell a story with multiple images than it is with just one. The bottom line is that shooting a series gives you more room to stretch out creatively.

SUBJECTS AND THEMES

A single portrait can be incredibly powerful and telling, but some subjects and themes just beg for more time and space. The series that immediately comes to mind for me is *Forty Years of the Brown Sisters* by Nicholas Nixon. Nixon captured his wife and her three sisters every single year over the course of four decades, starting from 1975. The whole point of the series was to capture the passage of time through his subjects, touching on themes of love, perseverance, and commitment. I can't imagine any way of capturing those values with such depth other than through multiple images taken over many years.

CONTINUITY

Beyond the subject matter, what made the *Brown Sisters* series so striking was its visual continuity: though their appearance clearly changed over the years, the sisters would always appear in the same order and each portrait was composed in almost the same way. He also remained committed to the same aesthetic throughout the series: each portrait was shot with an 8x10 camera on a tripod, using black-and-white film. Of course, this isn't to say that a successful portrait series requires every image to be near identical: having an aesthetic through-line (even similar lighting and tones) is just one of many techniques to help tie a series together.

COMMITMENT

Planning and preparing for a single portrait shoot can be a lot of work. . When I shot my first portrait series, *Ageless Beauty*, I expected the entire project—from casting through to post-production—to take six months. It ended up taking closer to a year and a half, three times as long as I'd planned for! When you're shooting multiple subjects (or even if you're shooting the same subject multiple times), know that it will always take longer than you think. Shooting a portrait series from start to finish requires time, energy, and commitment; but in my opinion, there is nothing quite as rewarding.

AGELESS BEAUTY

I started my career in New York shooting fashion photography, a genre that I eventually realized did not align with my interests and values. It bothered me that the models cast for my fashion editorials and ads would be incredibly young and yet were still heavily retouched to remove every little flaw or imperfection. I saw firsthand how this perpetuated an unhealthy, homogenous, and unattainable standard of beauty, and I felt like I was part of a machine that continued to mass-manufacture this lie.

With *Ageless Beauty*, I wanted to challenge the idea that youth was synonymous with beauty and celebrate the beauty of older women. I also wanted to address the double standards around aging for men and women by photographing women who felt even more powerful and attractive than perhaps they had in their youths. I exclusively shot women over the age of 50, from a range of ethnicities, nationalities, and walks of life. Besides some slight color correction for continuity, there was absolutely zero retouching of the subjects' bodies or faces.

HOW I SHOT IT

Ageless Beauty was cast via social media and online talent casting platforms (many of the subjects have creative arts backgrounds). It was shot in New York over the course of a year and a half in the same studio in Long Island City and at the same time of day (late afternoon) for continuity. All the subjects were lit using soft, front-facing natural window light and were positioned in the crease of a V-flat, which I flipped to create either a black or a white background. A silver reflector was angled slightly on the ground beneath the subject to add more fill and reduce facial shadows. The entire series was shot on a Canon 5D Mark II with a 50mm prime lens, which I find to be an excellent portrait lens that captures beautiful detail.

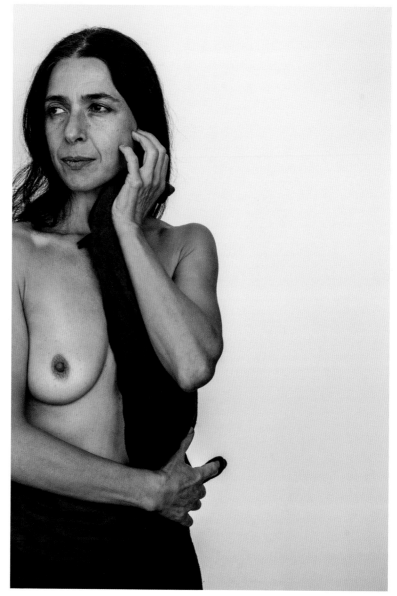

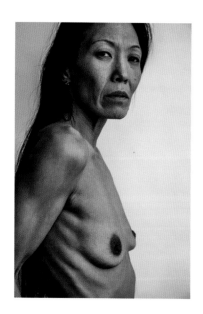

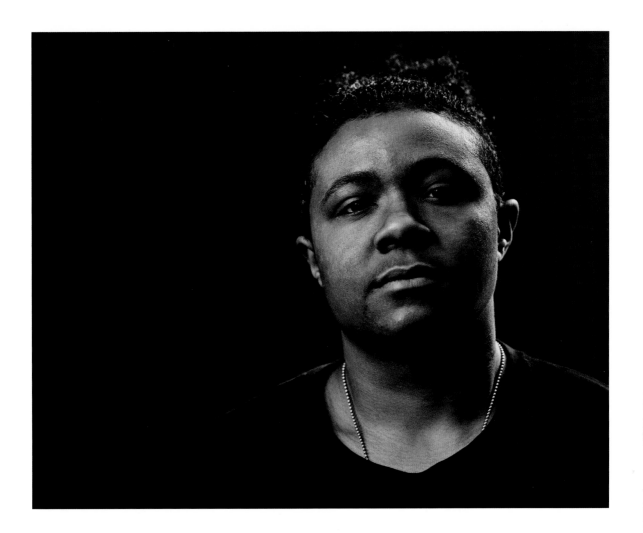

TRANSPARENT

A few years ago, moved by the experiences and stories of my transgender friends and family members, I shot *Transparent*, a portrait series highlighting and celebrating the transgender community. These friends and family members pointed out to me that most media portrayals of the trans community were exploitative, upholding damaging and dangerous stereotypes. Trans people were often fetishized, stigmatized, and lumped into a homogenous group, which led to widespread misperception.

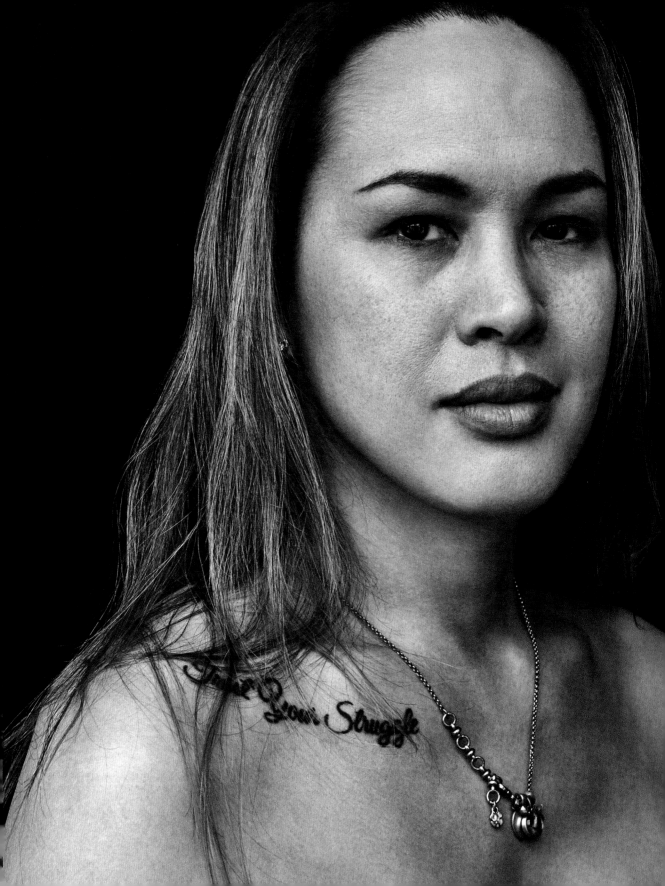

I created *Transparent* as a vehicle for their stories; but I also wanted to photograph trans people in a way that was beautiful and respectful, in contrast to what I was seeing at the time, which tended to be provocative and garish. I wanted to shoot classic, simple, black-and-white portraits of real, complex, normal human beings: mothers, fathers, and siblings; neighbors, coworkers, and bosses; students, cashiers, and writers. As a cisgender male, I was nervous about shooting this series and getting the message wrong, but I was grateful and humbled to be welcomed by every individual I photographed. I ultimately was privileged to be able listen to and offer a platform for their stories, which were in turn generously shared by media outlets such as *Harper's Bazaar* and *HuffPost*.

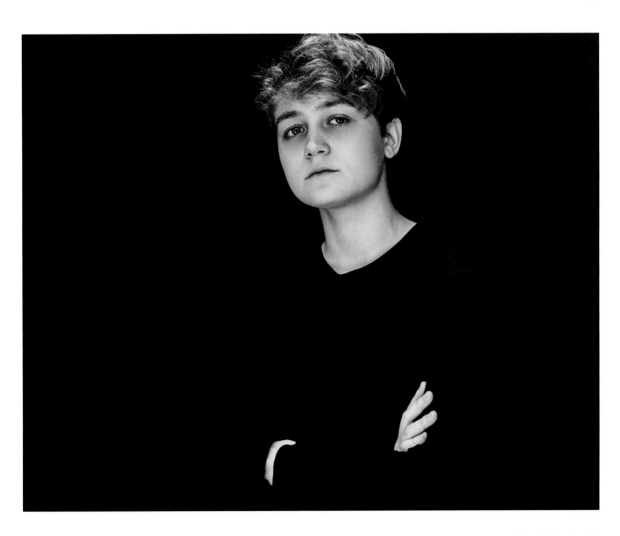

HOW I SHOT IT

The casting of *Transparent* involved
a combination of social media
outreach, word of mouth (friends
and friends of friends), and online
talent-casting platforms. It was shot
in a studio in New York over the
course of two years.

I wanted the portraits to be clean
and classic—capturing the essence
of each person rather than getting
too experimental with lighting or
composition—so I shot them in
a traditional studio setting using
mainly soft, front-facing window
light. This setup gave the subjects'
faces an even frontal fill. I also
placed black V-flats on either side
of their faces for a little negative fill
and subtle shadow, and I bounced
supplemental strobe light off the
white ceiling overhead to illuminate
features and details from above. The
entire series was shot using a Nikon
D3X and an 85mm prime lens.

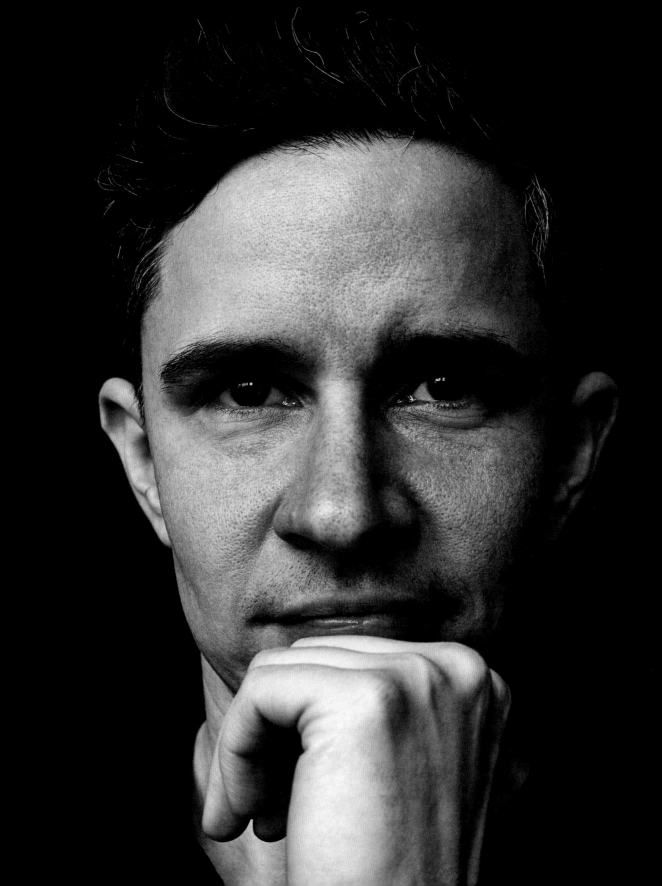

DOCUMENTARY

In its most narrow definition, documentary portraiture is a style of portraiture that provides a straightforward, accurate, and almost journalistic representation of its subject. Documentary photographers, much like documentary filmmakers, are expected to capture their subjects as they exist, without managing or directing them. But despite the somewhat hands-off approach to portrait-taking, documentary portraiture can result in some of the most stirring, honest, and emotionally powerful photographs.

Some classic examples include Jacob Riis' portraits of residents in New York City slums in the 1890s—so powerful that they helped inspire social reform—and Dorothea Lange's iconic and unflinching Great Depression portraits. Some of my favorite contemporary documentary photographers include New York-based Ruddy Roye, who captures photographs of the Black American experience today, and Doug Menuez, my friend and mentor, who documented Steve Jobs and other tech innovators throughout their struggles and successes in the 80s and 90s in his *Fearless Genius* project.

Given that documentary portraiture is not my area of expertise, I've tapped Doug for his wisdom. Here is his advice on how to shoot powerful documentary-style portraits, in his own words.

KNOW YOUR PURPOSE

First, you have to find a subject and a story you are absolutely fascinated by and inspired to document. You'll desperately need this inspiration, drive, and purpose because it will help to fuel all the work you have ahead of you.

For example, in 1985, I'd just come back to the Bay Area in San Francisco after covering the famine and conflict in Ethiopia and Eritrea for *Newsweek*. Having been a news photographer for some time, I'd already seen a lot of death by that point, but I was devastated by the sheer scale of this human catastrophe. I began searching for a way to use my skills to tell a positive story about tangible change and hope for the human race.

At around the same time, Steve Jobs announced that he would build a 'supercomputer' for education. He'd just been fired by Apple and was starting all over again. I felt a lightbulb go off in my head: I knew that education was the root of every social issue, and if Steve—who'd changed the world already—was working on education, then this was going to lead to something hopeful and great for humanity. I was deeply inspired, and this led to *Fearless Genius*.

DO YOUR HOMEWORK

Go in assuming that you know nothing about your subject. You can never do enough research, reading, and preparation. Learn as much as you can about the person, people or story you want to shoot. Also investigate who has the power to allow you access to your subjects and learn everything you can about them before pitching them your idea (sharing your portfolio and previous books or projects always helps). I cold-pitched Steve about documenting him during this time and ended up getting unprecedented access.

BUILD TRUST

Once you're granted access, spend a lot of time simply hanging around and conversing with your subjects before shooting any pictures. At the start, you want to establish a continued presence and demonstrate a genuine commitment to telling their story. Work first to gain your subjects' trust and acceptance before taking a single photograph. If it's a series, come back periodically and share the prints that you think will be appreciated by your subjects—many photographers often promise but forget to share their images, so it's important to stay true to your word.

Because I gained Steve's trust, I was also able to gain the trust of other leading innovators of the digital revolution, which helped expand *Fearless Genius* into a project that covered more than 70 startups over 15 years as they built the technology that changed our world. The resulting 250,000 images form a singular archive of a crucial era in our history. This would not have been possible without having first built genuine trust.

STAY OPEN

Sometimes things don't go according to plan: the story is not as visual as you imagined, or it takes much longer—and is much harder—than you originally anticipated. The main thing I've learned throughout these years is to keep your head in the beginner's mindset: stay open, curious, and humble throughout the process. The expert's mind is closed and overconfident. Ask a lot of questions, then ask a whole bunch more. I can't say it enough: assume you know nothing and listen, listen, listen.

Doug Menuez

HOW I SHOT IT

These documentary portraits were shot as part of a story featuring Grammy-nominated singer-songwriter Stacy Barthe. Shooting portraits of Stacy and her production team while she recorded her new album at a tiny recording studio in Midtown Manhattan was a huge challenge. I was photographing her as she was working, so I had to remain as discreet and unobtrusive as a fly on the wall, while also capturing real, intimate moments within a small, crowded, and dimly lit space. This lack of control over the subject's environment, along with learning how to adapt and troubleshoot on the spot, is one of the most common challenges you'll face when shooting documentary photography.

In the end, having the right camera helped tremendously. I shot with a Canon 1DS Mark III with a 24–70mm zoom lens, which was the ideal combination for the dim indoor environment. I find the 1DS Mark III performs beautifully in low-light situations at high ISOs, while the versatility of the 24–70mm lens allows you to capture both wide and closeup portraits perfectly—useful if you're shooting in cramped spaces and don't have much space to move around. In post-production, I applied a nice S-curve to the images to bring out the shadows and tone down the highlights. I converted the images to black and white, which helped to neutralize the unflattering studio lights.

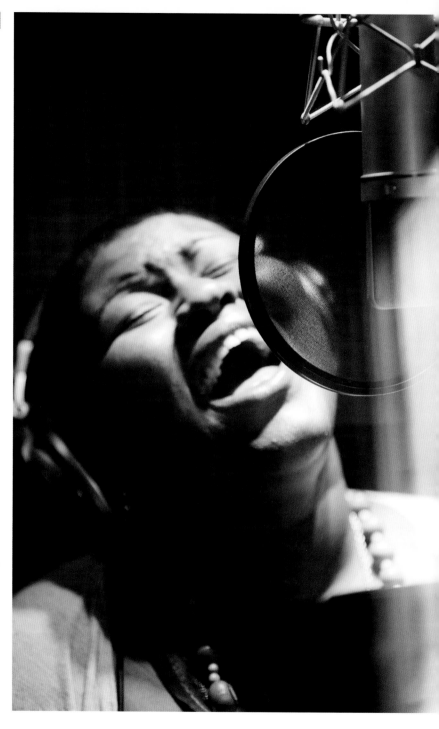

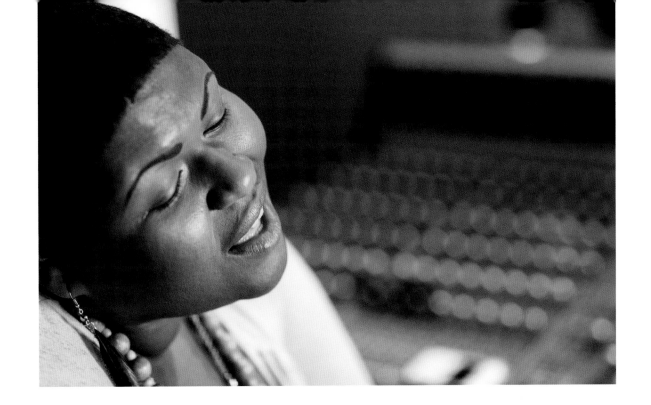

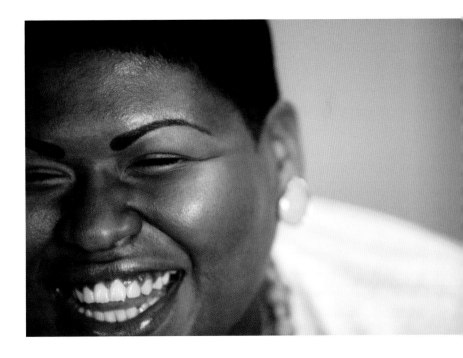

Camera: Canon 1DS Mark III
Lens: 24–70mm
ISO: 1600
F-stop: 2.8

When shooting documentary-style portraiture, it's necessary to keep an eye out for the details. There are so many clues about someone in the details: their hands, the jewelry they wear, their clothes. It's your job as a documentary photographer to look closer, to find the stories within the story.

In this case, for example, I could tell Stacy was a musician before she'd even sung a single note. All I had to do was look at her hands, adorned with tattoos of musical notes, and her bold and eclectic style, typical of performing artists— she even wore a T-shirt covered in piano keys! I didn't even need to capture her singing in a recording studio; the details spoke volumes about who she was and what she loved. Keep your eyes peeled.

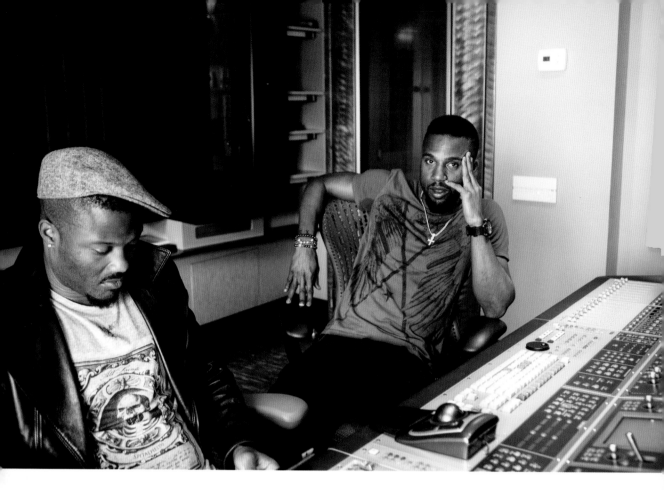

Camera: Canon 1DS Mark III
Lens: 24–70mm
ISO: 1600
F-stop: 2.8

Unlike regular portraiture, documentary portraiture can be borderline journalistic: rather than just a single portrait of an individual, it can be (and often is) a series of photos that reveals their life in several photographs, like the layers of an onion. Profiles in *TIME* and *Rolling Stone* are great examples of this. While the person remains at the center of the story, there's more space to explore where they live, how they work, and the people who help shape them.

It's a great opportunity to go wider and dig deeper.

Pictured here, for example, is music executive Wardell (left) and creative director CJ (right), who were both key players in recording Stacy's new album. They were there day in and day out, and during the shoot it was clear that they were instrumental to the album's creation and a part of the singer's story that needed to be captured, too.

EDITORIAL

'Editorial' commonly refers to images that are published alongside text in magazines or online publications, or in some cases (such as fashion editorials) they can stand on their own. Publications like *Rolling Stone*, *Time*, *GQ*, and *Vanity Fair* are known for their editorial portraits and celebrity profiles, and I strongly recommend browsing through their covers for some inspiration and to see the benchmarks for this genre.

What really distinguishes editorial portraits from regular portraits, in my opinion, is the production value. It's very rarely just a photographer and their subject, but rather a whole crew consisting of hair and makeup, stylists, assistants, producers, and lighting techs. There are call sheets and shooting schedules, and planned-out looks. Afterwards, the images will be professionally color-corrected and retouched to perfection. As a result, editorial portraits are typically more polished and stylized.

Personally, I tend to think of editorial portraiture as more of a style than a strict category or genre, and as such, open to imitation. Just because a portrait doesn't appear in a glossy magazine, ir doesn't mean that it can't look like it belongs in a glossy magazine. That polished, stylized look and feel, that high production value, the storytelling and the drama of editorial photography—all of this can be applied to any photograph. Here's how you can make any portrait look like it belongs in the pages of *Vogue*.

COLLABORATE

Editorial photography is, above all, a collaboration—I think more so than any other kind of photography. By its very nature, it brings together talented artists who are the best at what they do (e.g., makeup, fashion styling, lighting, production) to create something special. If you're lucky enough to be hired to shoot an editorial, don't take for granted the opportunity to work in a team alongside other creatives. But even if you're not shooting a magazine editorial, you can still infuse that same level of artistry to your work by joining forces with other professionals. Hire professional makeup and hair stylists, get a someone onboard to experiment with different looks, or even just hire an assistant to help you perfect the lighting and make your shoot more streamlined. All of this adds to the production value of a portrait.

LEAVE YOUR CREATIVE COMFORT ZONE

When *Bombshell Magazine* asked me to shoot an edgy, Marilyn Monroe glamor-inspired editorial featuring the reality star Blac Chyna, I was apprehensive at first. The references I'd been shown—over-the-top hair and makeup, bold experimental lighting, high drama—were nothing like the portraits I usually took, which are generally classic, clean, and minimalist. But when I sat down with the creative team, I realized it could be a cool opportunity to do something different. It ended up being one of the most fun shoots I've ever done, and I was so pleased with the final product. Bottom line: the best editorials are creative, boundary-pushing, and even outrageous. Flip through some fashion or art magazines for inspiration and take note of anything that speaks to you. Don't be afraid to play.

BE ADAPTABLE

Shooting an editorial portrait involves more moving parts than any other kind of portraiture. You have talent and crew interacting with one another, you have sets and props and wardrobe, you have a vision that—no matter how prepared you are—won't always materialize exactly as you'd imagined. That's okay. Embrace the chaos rather than fight it. Outfit fail? Zoom in and focus on the details and accessories. Bad light? Turn it into a whole mood. Sudden inclement weather? Shoot in the rain! At the end of the day, it's really not all that serious. Some of the best editorial portraits can happen by accident.

HOW I SHOT IT

Throughout the entire *Bombshell* shoot, the magazine's creative director and I worked together, bouncing ideas off one another constantly (some ideas worked, and some didn't). One idea that did work was to ditch the backdrop entirely and photograph Blac Chyna against a window overlooking downtown Los Angeles so that you could see the city lights twinkling in the background. Because there was already so much happening visually in the frame, I was afraid it would appear too busy. However, it turned out just right, and the resulting image ended up being the cover.

Because the profile we were shooting for was also a fashion and beauty story, I made sure to compose each portrait in a way that showed off the artistry of the amazing hair, makeup, and wardrobe stylists. The creative references called for a moody, glamorous, old-Hollywood vibe, so I opted for softer diffuse lighting, which I achieved using a large soft box paired with continuous tungsten Fresnel light. I shot with a Nikon D850 (great for higher ISOs) and an 85mm prime lens, my go-to combo for capturing beautiful clarity and tonal range in lower-light situations.

COMMERCIAL

Commercial portraiture commonly refers to portraits that are taken for commercial purposes: websites, promotion, marketing and advertising, or internal communications. This is entirely different from portraiture that's been commissioned by private individuals for themselves; for example, family portraits or wedding photography. The ultimate look and feel of a commercial portrait varies widely, but they're typically characterized by a polished, glossy look and a high production value.

Because these portraits are entirely client-driven—you're usually given a brief asking for a very specific deliverable—there isn't as much room for creativity. Some photographers (including me) feel restricted when shooting commercial portraits. For some photographers, however, this is a breath of fresh air because it takes the creative pressure off a bit, and you can focus on the technical aspects of how to achieve the specs. Commercial portraiture is also, not surprisingly, the most lucrative kind of portraiture you can do today.

If there's one thing I've learned from my own personal experience, it's that commercial portraiture is less about the subject and more about satisfying the needs of the client. For this reason, it pays to do your homework: learn as much as you can about the client, study their previous campaigns, headshots or social media posts – whatever it is they've commissioned you to shoot – to get a sense of their aesthetic.

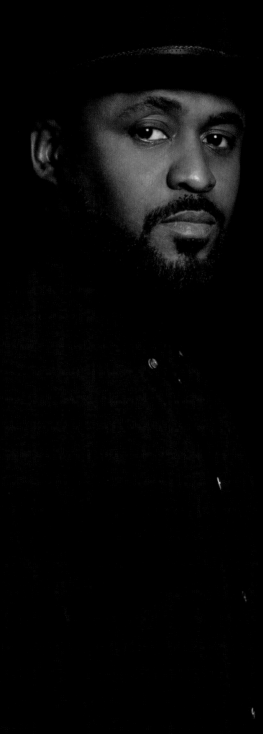

Camera: Nikon D850
Lens: 50mm prime
ISO: 100
F-stop: 8

I want to share here a key tip for creating effective commercial portraits: be intentional. Being crystal-clear about the intended purpose of the portraits you're taking will keep you focused and on-track during a fast-paced and high-pressure shoot day. In this shoot, for example, really understanding the intention of the client (promotional portraits for media and PR) and asking for specific photo references set me up for success. I worked out a shoot schedule to ensure I'd hit every look and shot they wanted—and I did, despite shooting in less-than-ideal pandemic circumstances.

HOW I SHOT IT

At the end of 2020 I was hired by actor and TV host Wayne Brady's production company to shoot promotional portraits for several upcoming television shows. They were after classic portraits in a variety of looks and against different backgrounds, which was a challenge, given that we were shooting at his home in Los Angeles, with a small crew and a very barebones set—the exact opposite of a typical commercial shoot setup.

The pandemic limited our access to resources, and we had just two backgrounds (a grey seamless and hand-painted blue muslin) and a single strobe umbrella. The crew consisted of myself, one photo assistant, and a makeup artist; and I used my trusty Nikon D850 and 50mm prime lens.

Even with our skeleton crew and limited resources, the portraits turned out great and went on to feature in *Variety*, *Los Angeles Times*, and television network promos. The lesson I learned from this shoot was that you don't need a fancy set, a complex lighting setup, or a robust crew to pull off a successful commercial portrait. It just takes a backdrop, one good light, and a camera-ready subject—which is great news if you're just starting out and trying to build your own commercial portraiture portfolio.

POST-PRODUCTION

In my experience, shooting for ad agencies and commercial clients like Apple, post-production—namely retouching—is not something you generally have to worry about. But sometimes, for smaller commercial jobs, your client may ask you to handle all post-production needs. In either case, my advice is to get your images as correct in-camera—via lighting and the techniques outlined in Chapter 3)—rather than relying on extensive (and expensive) retouching to get the portraits to a good place.

OVERDELIVER!

My friend and mentor Doug Menuez (see page 85) taught me to always go the extra mile and have a beginner's mindset, no matter how seasoned you are as a photographer. I think this is especially relevant when it comes to commercial portraiture. Going above and beyond for every client—at every stage of the process—is a mindset that's helped me take better pictures (as well as get hired again and again).

For example: sending the client creative references prior to the shoot to ensure that you're unequivocally on the same page; being communicative and receptive to feedback throughout the entire shoot day. Afterwards, sending over more photos in your final selection than initially agreed upon. I always like to make the client feel that they got more than what they were expecting.

SPECIAL EVENTS

Photographing special events and celebrations, such as weddings, engagements, or birthdays, for example, is in my opinion one of the most challenging types of portraiture. There are so many moving parts, so many things beyond your control: not-ideal lighting, changing weather conditions, time constraints. Unlike in studio portraiture, photographing events and celebrations goes far beyond creative challenges— it's underscored by the immense pressure of capturing a milestone moment in someone's life. (There are no re-dos on wedding-day portraits!) It's an enormous responsibility that makes me nervous just thinking about it. I have the greatest admiration and respect for photographers who take portraits for events and celebrations.

Because shooting event portraits is also not my genre of expertise, I've invited my buddy Scott Clark, owner of Clark Studio and one of *Harper's Bazaar*'s Best Wedding Photographers in the World, to share his wisdom. Here are some tips for capturing portraits for events and celebrations, in his words.

FIND THE STORY

It's so important that your images translate into a story for your client, so you'll want to start by taking some establishing shots of the location and decor. These establishing shots will generally be taken on the day of the event, once it's all been set up, but before guests arrive. But because you're working with a time constraint, there's no harm in doing research on the location in advance (you can even visit prior to the event) to familiarize yourself with it, so that you can hit the ground running on the day of the event. I like there to be a good mix of these establishing shots and detail shots (e.g., the wedding dress, cake, and place settings) layered in amongst the actual portraits. I find that this really rounds out and completes a story.

GIVE CUES

To get people to look comfortable and act naturally in front of the camera, I like to put them in motion. Have them walk down the street, look in a different direction, or if you're photographing couples, whisper something into their partner's ear. I'm always looking for the organic moment. They may be thinking, "Oh, that's really cheesy!" But then they create a reaction that is completely natural—and that's the moment we want to capture.

Personally, I'm not a fan of candid photography. If I shoot 10,000 candid photos at an event or wedding, I may get two or three images that I can use (and I would never be hired again). What I have found is that people like being told what to do in front of the camera; they just need a little direction. It's the photographer's job to capture those real emotions and moments in between.

TIME MANAGEMENT

Have a solid game plan for the shots you want to capture. Have a shot list that you can refer to and just go down the line. I always send out a shot list request before an event or wedding, which helps me understand what is most important to the client. In general, shoot the details first (establishing shots, decor), and then move to putting people in those shots.

For weddings and events, your clients may be the bride and groom, but your real agent is the planner or producer. You are there to help things run smoothly so they get their next million-dollar job, and they will return the business tenfold.

STAY OPEN

Very little in any event is controlled. You have to know what will come next, but also expect all plans to get changed! Again, it's best to fully scout your location ahead of time and have backup plans for light, movement, weather, and attitudes.

Scott Clark

HOW I SHOT IT

I'm usually too intimidated to shoot
any celebrations or milestone
moments, but I couldn't turn down
the opportunity to shoot maternity
portraits of my friends, Kaz and
Diego on Venice Beach in Los
Angeles. Being longtime friends, I
had the advantage of my subjects
being comfortable and familiar with
me straight off the bat, which made
it easy to get authentic pictures.

I wanted to capture Kaz and Diego's
chemistry and rapport, so most of
the shoot was simply me snapping
away while they walked along the
beach, which resulted in some
carefree candids.

However, I also wanted to get some
traditional maternity portraits—the
classic hands-on-belly shot, for
example—so I had them pose for
a few, which ended up being some
of their favorites.

I shot these portraits at sunset
using my Nikon D850 with a
24–70mm lens, which is a great
combination for shooting people and
events. The Nikon D850 is a solid
workhorse camera that shoots well
in continuous mode so you'll never
miss a precious moment, while the
24–70mm lens is a super versatile
lens that captures wide, medium,
and closeup shots beautifully.

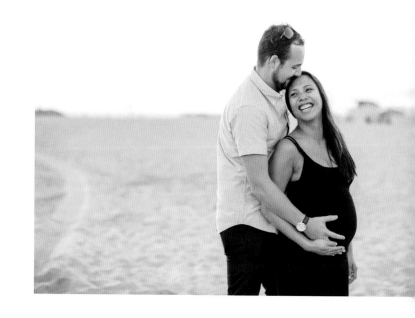

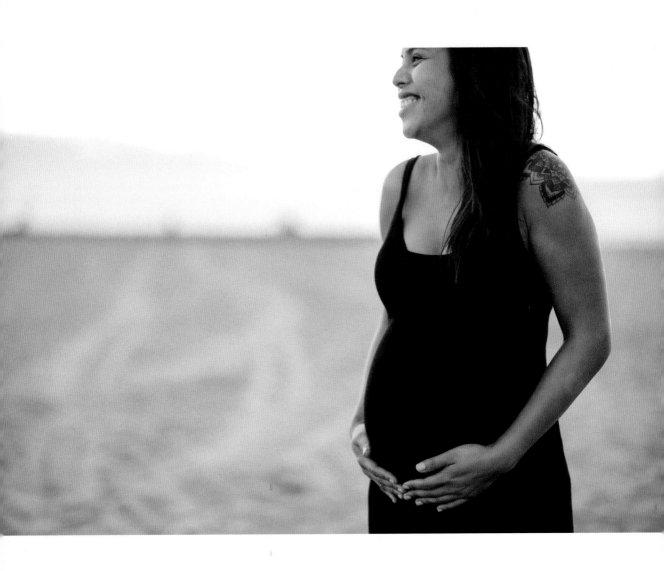

SELF-PORTRAITURE

Usually, when we think of self-portraiture, we tend to think immediately of selfies— of Instagram and social media, a culture of narcissism, vanity, and self-obsession. Self-portraiture typically gets a bad rap. This is a shame, because if you look back at history, it is a legitimate art form, and something that artists have been doing for centuries (see Rembrandt, Paul Gauguin, Frida Kahlo, Robert Mapplethorpe, and Cindy Sherman for examples).

Before self-portraits became synonymous with instant iPhone selfies, they were a serious means of experimentation—a vehicle for self-exploration and self-expression, a way of showing the world how we artists view ourselves. Self-portraiture is an opportunity for artists to depict themselves as the main subject for once, as heroes in their own stories. "The artists themselves dictate the terms on which we are invited to judge them," writes artist Liz Rideal on the genre of self-portraiture. It's a way of freezing, if only for a moment, our own transitory existence.

It's also a great way to hone your technical skills. Van Gogh—a master self-portrait artist—was once quoted as saying: "If I can manage to paint the coloring of my own head, which is not to be done without some difficulty, I shall likewise be able to paint the heads of other good souls, men and women." Likewise, I use self-portraiture primarily to experiment with light, posing, and composition. It's a way for me to practice techniques that I'll later use on my subjects in an actual studio shoot. I also think that knowing what it's like to be on the other side of the camera helps us to be better and more empathetic photographers.

USE A TRIPOD AND SELF-TIMER

Ditch the basic, stretched-out-arm selfie! Set your camera up on a tripod and use a self-timer on burst mode, which allows you to take multiple shots in succession. Most camera models allow you to set a delay of at least ten seconds, which gives you enough time to get into place. To make things even easier than the self-timer method, you can use a remote trigger, which eliminates the need for you to physically get up and press the shutter.

EXPERIMENT

Use this as an opportunity to play with different expressions, poses, and perspectives, though it may feel silly at first. Use this as an artistic exercise to get out of your comfort zone. Sit yourself on the floor, sit in a chair, stand up (make sure you adjust your camera each time so that you're in the frame). Experiment with looking straight at the camera, looking off to the side, crossing your arms, framing your face with your hands. Shoot yourself from a high angle or a low angle, shoot your reflection in a mirror or through a pane of glass. Use an old CD and direct the metallic part at your face so that rainbow beams of light play on your features. Use makeup or props or different outfits and role-play (study the portraits of Cindy Sherman for inspiration). Use a Polaroid or a film camera. Shoot black and white.

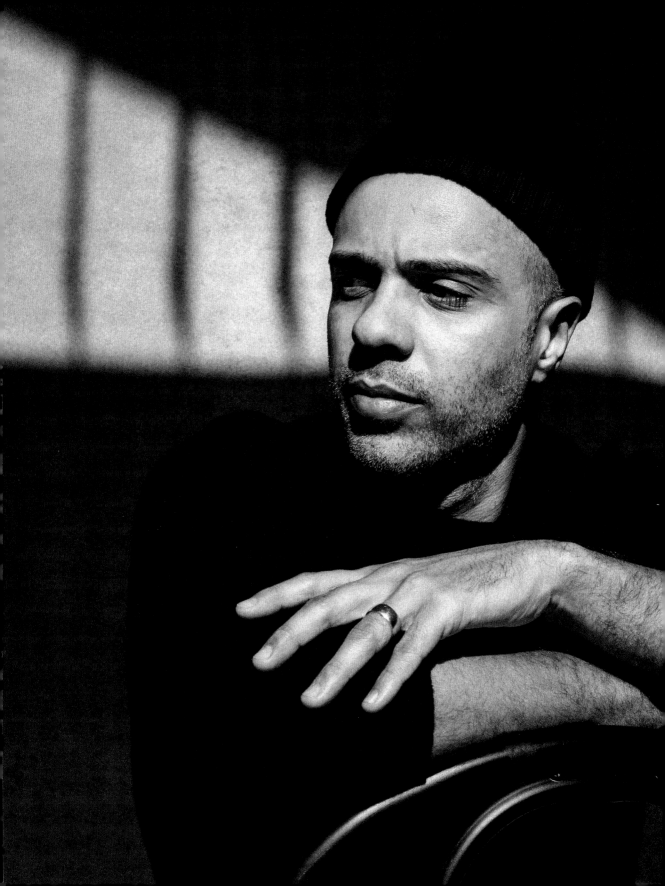

BE VULNERABLE

Frida Kahlo began creating self-portraits when she was bedridden after a serious bus accident—she had a mirror set up above her bed so that she could study and paint herself. Similarly, photographer Patricia Lay-Dorsey, when diagnosed with progressive multiple sclerosis, chronicled her daily journey through self-portraiture as she began to accept the limitations of her body. Throughout the COVID-19 pandemic, thousands of people documented their experiences in quarantine via self-portraiture as a creative outlet and as a means of healing. Why not see if you can capture yourself in a state when you feel vulnerable, sad, anxious, or lonely? Very rarely do we capture ourselves during moments in time that are difficult or challenging. Take a self-portrait after a breakup or career loss, or when you're feeling insecure or low. What is portraiture if not capturing a fleeting moment in time?

HOW I SHOT IT

I set up a grey, hand-painted muslin backdrop in my loft, the same way I would in a studio, directly in front of a large window with a lower and upper set of blinds. Because the daylight was so bright and harsh, I lowered the bottom shades but kept the top set open to let a triangle of light into the upper half of the frame. I set up my Nikon D850 on a tripod with a self-timer (20-second delay, nine consecutive shots) and tried a new pose with each series of nine shots. In the third picture (see page 108), I set up the camera at a slightly lower angle and positioned myself directly in the sun—which was purely experimental because I never shoot with harsh light on my subject's face—but I like how it turned out.

PLAY WITH LIGHT

Self-portraiture is the perfect opportunity to try out a studio lighting setup on yourself. You can also get creative and use the light sources within your house, like a bedside or desk lamp. Alternatively, try shooting by a large window in the late afternoon, which is always my preferred light source—the soft, natural light minimizes harsh shadows and creates a more flattering portrait (if that's what you're going for). If the sunlight is harsh and direct, try shooting your silhouette. Use this time to study how light falls and experiment with light-shaping (see page 16).

3

TECHNIQUES

DETAILS
POSING
FRAMING
ANGLES
MISE EN SCÈNE

———

In Chapter 1, I laid out the groundwork for taking an effective portrait. But the truth is, there's no magic formula. Sometimes you have the perfect subject and follow all the compositional rules to a tee, and your image still doesn't land quite right. On the other hand, you can break all the rules, shoot off-the-cuff, and surprise yourself with something totally inspired. This is the beauty of taking photographs and especially taking photographs of people!

That said, armed with the basic guidelines from Chapter 1 and a few handy techniques, which I'll outline in this chapter, you have a very good chance of creating a portrait that's beautiful and interesting. In this chapter, I'll share four things I like to focus on that almost always add something special to a portrait. You can use them alone or together, or simply as a jumping-off point to try something different entirely.

DETAILS

One of my favorite techniques for taking my portraits to the next level is to bring out the details. In my opinion, it's the small things that make a person special and unique: laugh lines, freckles, wrinkles, a tattoo, or chipped front tooth. Whenever I'm trying to take a portrait and it seems to be lacking that special thing, I look to all these little details as breadcrumbs that will eventually lead me to a perfect portrait.

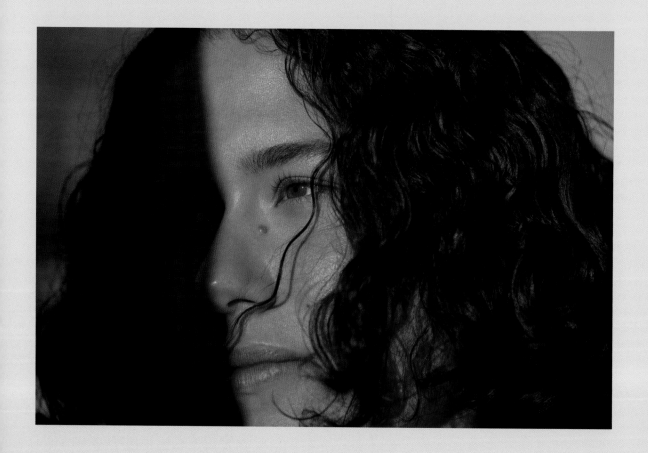

ZOOM IN

The American-Hungarian photographer Robert Capa once famously said: "If your pictures aren't good enough, you're not close enough." Though there's some debate over whether he meant that literally or figuratively—getting closer can also be interpreted as becoming more curious or emotionally invested in your subject—I like to think he meant getting physically closer to your subject, close enough to really see them.

In my own experience, getting up close to your subject (with their full permission, of course) is an incredibly powerful portrait technique. I like filling the frame with their face and getting all the tiny things in crisp focus—the moles and subtle flecks of color in their eyes—that you can't possibly pick up with a wider shot.

FIND THE (OTHER) STORY

What I love about details is that, if you look carefully enough, they can reveal a different story about an individual than the one at face value. For example: an environmental portrait (page 46) can tell you how and where a person lives, their socioeconomic status, or what they value. But zeroing in on the details? That can tell you a different story altogether. Look for the 'other' story, the one that's not so obvious. The scars that reveal a not-so-perfect past, the peekaboo tattoo from beneath a sleeve, a dimple from an old eyebrow piercing. Hands, teeth, and eyes reveal a lot. Look beyond the surface. Humans are complex and messy, we contain multitudes.

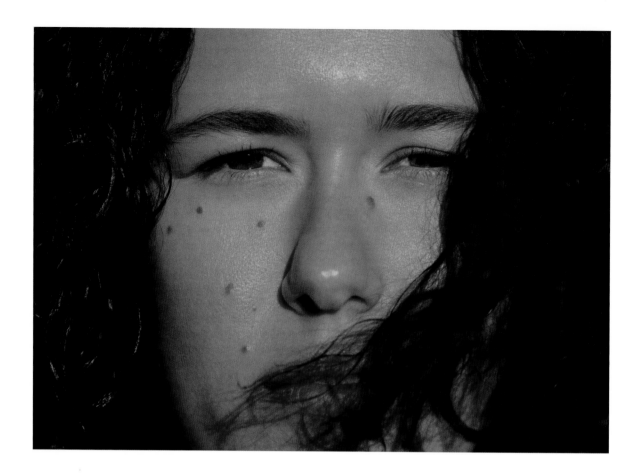

HOW I SHOT IT

I initially photographed Tyler as part of a lifestyle shoot in La Perouse, near Sydney, Australia. But I found that with every wide shot I took, her features—the moles on her face, her golden eyes, and curly hair—were eclipsed by the scenery. I opted to do some tighter shots of her face, using a Nikon D850 with a 105mm macro lens, my go-to portrait lens for picking up terrific detail. For the wide shot, I used the Leica Q2, which has a wider lens that could capture more of the landscape without sacrificing detail quality.

FIND THE IMPERFECT

I live to find and photograph imperfections. I think they're the most beautiful thing on earth. Crooked noses, wrinkles, pores, weathered hands and dirt under fingernails, grey roots, and stretch marks. Next time you photograph someone, look for the feature that society has conditioned us to hide or downplay. A prominent nose? A gap-toothed smile? Big, frizzy hair? Place that front and center. Our so-called 'flaws' are what make us awesome and interesting.

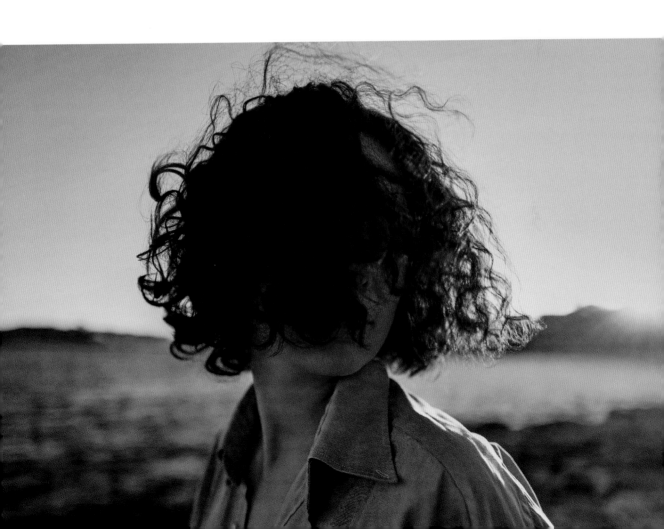

POSING

A beautiful, natural pose can truly elevate a portrait, so
knowing how to pose your subject is a great technique to
master. Note that I use the term 'posing' loosely to mean
positioning a subject in a way that's flattering for them.
I personally avoid classic model poses, like hands on hips
or looking over the shoulder altogether, because I think they
make subjects appear contrived and unnatural.

It is difficult to give specific instruction on how to pose a
subject because, in my experience, posing is very situational.
The perfect pose is entirely dependent on the individual, their
environment, the mood, the lighting, and the type of portrait
you're taking. Finding what works requires a lot of patience;
you need to be in tune with your subject, study the scene, and
almost let it come to you. Once you're present and fully aware,
you might consider using the following techniques, which
I use often.

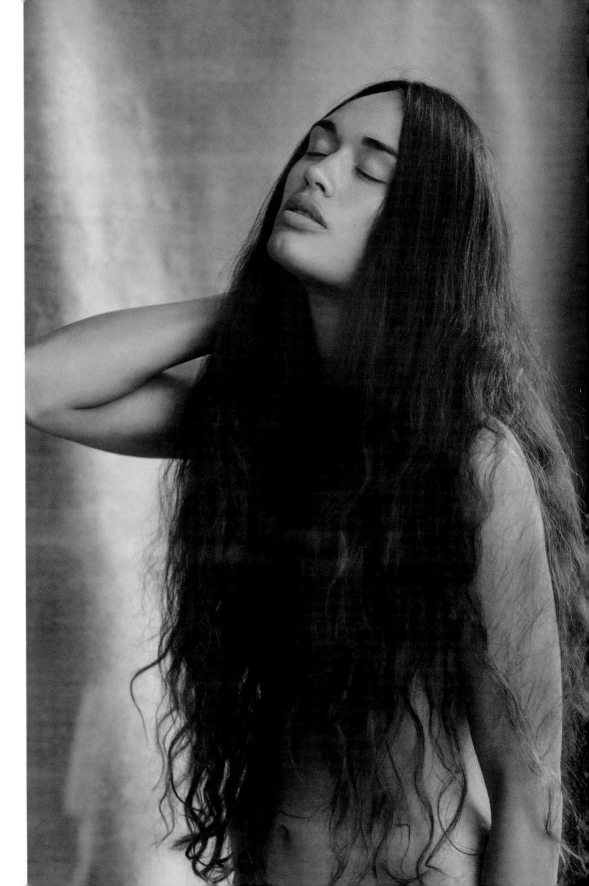

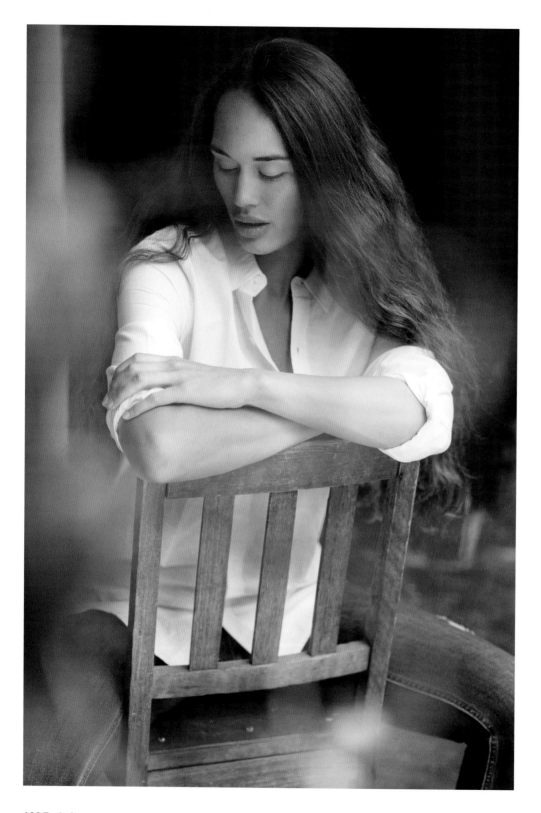

Camera: Nikon D850
Lens: 85mm prime
ISO: 640
F-stop: 5.6

Seated portraits are my go-to when a subject is struggling to find a natural standing pose. This is a good hack for subjects who are inexperienced before the camera, though even professional models can appear more comfortable when seated. I used a chair here because it was there, but you can use a stool or an apple box. Just make sure your subject doesn't slouch, and shoot from a slightly higher angle.

FORTY-FIVE DEGREES

Most people, professional models included, look better when posed at a slight angle rather than front-on. Have your subject turn their body at about a 45-degree angle away from the camera so that roughly three-quarters of their body shows. Alternatively, you can move yourself so that you're photographing your subject at that angle. Having your subject place one foot behind the other and bend the leg closest to the camera can also help to impart a bit more curve and shape to the body.

ENCOURAGE INTERACTION

On page 103, events photographer Scott Clark recommends encouraging interaction between people, particularly when photographing couples. Having subjects talk to each other, getting one person to whisper in the other's ear, or stroke the other's hair—simply engaging in natural, fluid movements—translates to more dynamic, natural-looking portraits. For the same reason, I like to encourage interaction even when I'm shooting a solo subject. In the pictures of Larissa shown here, for example, I had her interact with the chair, sitting on it in a way that felt most natural, resting her arms on the chair back. I also asked her to interact with her hair, brushing it away from her face, flipping it over her shoulder, twirling a lock between her fingers. Having the subject interact, even with an inanimate object, can help to elevate a portrait.

I shot this series of Larissa specifically to demonstrate the posing techniques I use most. Note that each pose is subtle and simply an enhancement of her natural movement—that is what you want to go for every time (unless, of course, you're specifically going for something edgy). Note how her hands are both occupied and relaxed in every shot. All five portraits were shot on a Nikon D850 with an 85mm prime lens using exclusively natural light.

POWER OF THE GAZE

The direction of your subject's gaze can be an excellent storytelling tool. Having them look directly into the camera can signify power, confidence, boldness, and empowerment. It also means the subject looking the viewer is directly in the eye and that can spark an immediate connection. Alternatively, having them look away—directing their gaze beyond the frame—adds tension and intrigue and can make your subject appear more mysterious, or, depending upon context, it can make them appear shy, wistful, or evasive. Your subject's gaze can powerfully alter the portrait's mood, so it's an important consideration.

BALLET HANDS

The placement of hands can often be a challenge in a portrait: you don't want them dangling awkwardly ("dead hands") or, even worse, positioned in some kind of stiff, forced, unnatural way. I always like to give a subject's hands something to do, such as have them gently frame their face or highlight a body part. Another trick is to give them an object or surface, such as a wall, to touch. If my subject is struggling, I ask them to imagine a ballet dancer's hands, how they're a natural extension of the arms, relaxed but not limp, fingers loose, soft, and graceful. The bottom line: hands should always sit lightly and comfortably on the face or body and should never be tense.

FRAMING

When I speak of framing as a portraiture technique, I'm talking specifically about creative framing: using elements of a scene to make a frame within your frame and draw attention to your subject. You can use the existing elements of your scene to highlight your subject (such as a tree, tunnel, or archway), or you can add elements (a physical frame, shadow, or light). Either way, creative framing can help to add depth to an otherwise flat portrait, add context to a shot, and draw the viewer's eye towards your subject. Here are some of my favorite ways to frame a subject.

WINDOWS

A window is probably the easiest and most obvious 'natural' frame that exists. Simply place your subject inside of the window's frame, consider your composition, and then shoot. I usually like to shoot from the outside looking in. You can reduce glare with a polarizing filter or shoot at a larger aperture to create a shallow depth of field, excluding reflections in the window from focus. The outside-in method, apart from framing the subject, gives the viewer the sense that they're peeking in on a moment. Alternatively, you can shoot from the inside looking out, which is what I did in this case.

HOW I SHOT IT

This portrait was a part of an urban fashion editorial I shot in New York City. A lot of the shots I'd already taken were highly posed and structured, so I wanted a shot that felt fluid and had a little more depth. I played around with shooting from inside a parked car through the window for a surreal vibe. I framed the shot with the car's door frame to create layers: it has an obvious foreground, middle ground and background. The resulting shot remains one of my favorites and ended up in the final editorial. I shot the whole thing with a Canon 1DX Mark II using a 70–200mm zoom lens.

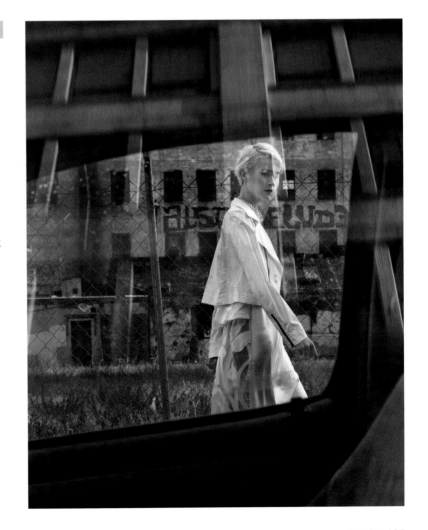

HOW I SHOT IT

This portrait was part of a men's fashion editorial that I shot in a really cool, unusual loft in downtown Los Angeles. It was wrapped in huge windows and had floor-to-ceiling beams throughout—very raw and industrial. Even though most of the photos I took were classic fashion portraits set against a solid background and lit with strobes, I wanted to get a shot using the beams and windows. These features created nice layers in the portrait, and the varying degrees of light and shadow helped to frame the subjects nicely. I shot the entire editorial using a Leica SL with a 50mm prime lens.

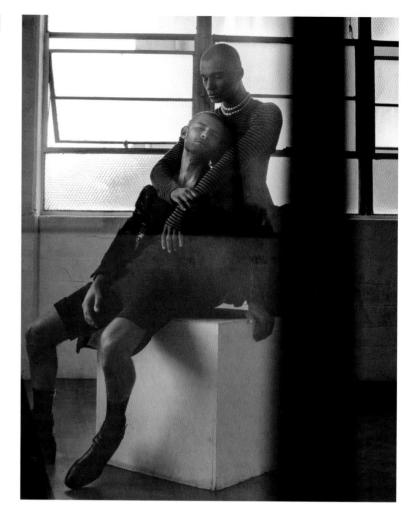

ARCHITECTURE

Existing architecture is another easy and effective way to frame a subject, particularly in an environmental portrait. I like to look for doorways, arches, or columns to place my subject within, or even geometric shapes like squares, circles, or triangles. It may frame the image on four sides or just two or three sides. The edges of the frame itself can also be variable— your subject can be framed on one side by a wall and a window on the other. In this case, for example, I used a single beam at the center of a photo studio and a series of windows in the background to frame my two subjects, real-life couple Matthew and James.

DARKNESS AND LIGHT

If you're shooting in a studio or an environment without natural or architectural frames, another easy way to isolate and highlight your subject is to surround them in darkness. Having your subject partially illuminated as I have done in the image here can also frame them nicely; remember, a frame doesn't need to go all the way around in order to do its job.

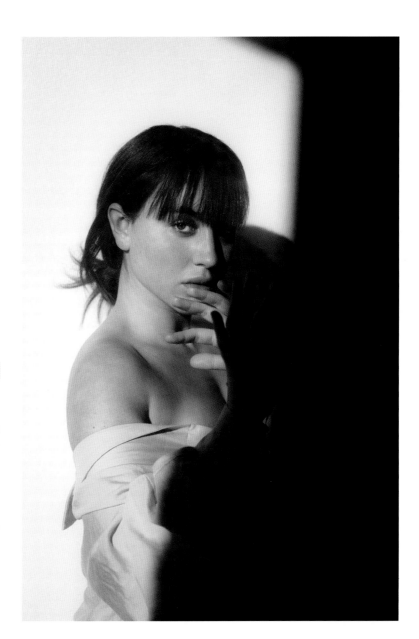

HOW I SHOT IT

Unlike in my shoot with Matthew and James, the Sydney studio where I photographed Patience didn't have a lot of architectural elements that could make for a good frame, so I used light and shadow instead. I found a corner of the studio that was half illuminated by sun and half shrouded in shadow. The contrast between the hard, dark shadow and the bright sunlight acts as a natural frame. I shot this using my trusty Nikon D850 with 50mm prime lens.

ANGLES

The angle at which you shoot your subject makes a huge difference to how they are perceived by the viewer. I'm not talking about angles in terms of posing (see page 120), but rather, where your camera is placed when you take the shot: high, low, or at eye level.

Before I get into the three main angles here and what each one can help you achieve, I do want to mention that subtlety is key, at least it is for me. I rarely ever shoot a portrait at dramatically high (bird's eye) or low (worm's eye) angles as it makes a subject look unnatural. Rather than smack the viewer over the head with the angle, I use it in conjunction with posing and framing to emphasize a mood or a vibe.

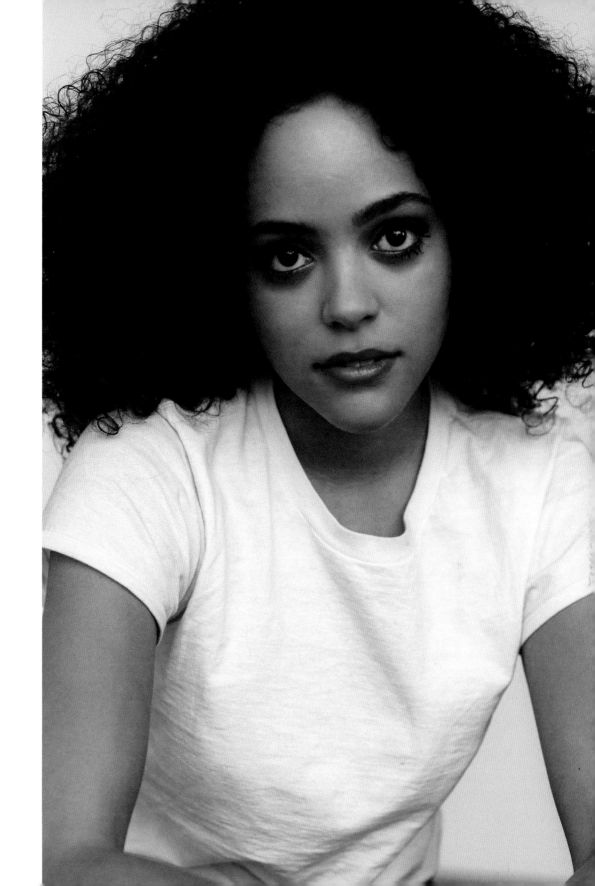

I first shot Quintessa as part of my *Transparent* portrait series in New York, and then once again in a separate portrait shoot in Los Angeles. Being an actress, she had a natural range of expressions and emotions that were easy to enhance using different angles, though you can experiment with angles on any subject, including yourself (see page 106). I shot these portraits on a Leica SL with a 24–90mm lens using exclusively natural light.

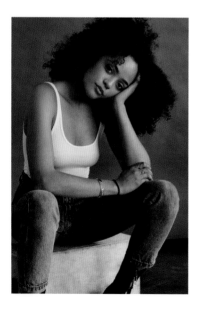

HIGH ANGLE

Photographing a subject with the camera above their eye level is popular for many reasons. It's generally more flattering, as it renders the subject's face and body as slimmer, hides a double chi,n and makes the eyes appear larger. For all its flattering effects, it can also make a subject appear more vulnerable or even childlike. Because you are in a position of dominance (literally looking down upon the subject,) they may appear timid and weak. Again, subtlety is key. Unless you want to make your subject appear submissive or diminutive—and that can be a deliberate effect—keep the angle slight. In the portrait at right, for example, the subtly elevated angle helped to give Quintessa an innocent look.

LOW ANGLE

Conversely, shooting with the camera below the subject's eye level can have the opposite effect. Because you are shooting up at the subject, they automatically appear more powerful and dominant. In film, low-angle shots convey to the audience that the character is heroic, strong, or domineering, and it's the same in portraiture. In my work photographing corporate executives in the music industry, my clients often preferred that I shoot from this slightly lower angle so that the execs appeared taller and more authoritative. It's best to use a wide-angle lens if you're really after that larger-than-life effect. But again, I like subtlety. In the portrait below left, rather than the doe-eyed, innocent, and childlike effect of the previous higher-angle shot, the slight low angle helped Quintessa give off a superior, nonplussed vibe.

EYE LEVEL

Shooting at eye level generally gives off the most neutral vibe and typically creates the best connection with the viewer, particularly if the subject is looking directly into the lens. The subject appears neither submissive nor domineering, which usually comes across as relatable and honest. For these reasons, I gravitate most towards shooting my subjects at eye level, unless I'm trying to highlight a specific quality or personality trait.

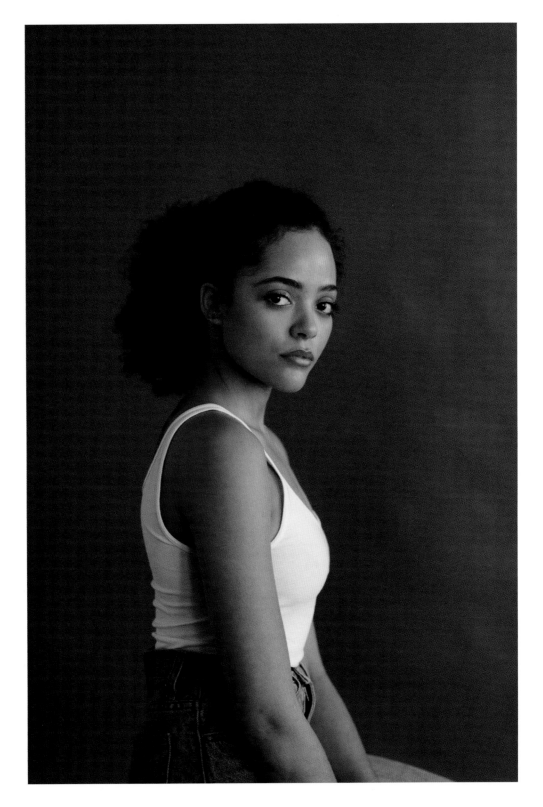

MISE-EN-SCÈNE

Mise-en-scène is an adopted French term used in film that roughly means "setting the scene." It refers to everything in front of the camera, from the props and set to the lighting and placement of the actors, all of which works together to convey meaning. As photographers, we can borrow this same principle. In portraiture, as in film, we can use various elements to 'set the scene' and create a specific mood, look, or vibe.

PROPS

In a movie, a set designer will often add props to help convey meaning. The same goes for a photograph: objects within the scene can contribute to the story, mood, or idea. In the photograph overleaf, I wanted to capture Rosa's complexity and duality, the different masks she wears—like we all do—in her professional versus her personal life. To convey this duality, I set up a dresser with two mirrors. One mirror is at the center of the frame, in which she appears elevated, confident, and dominant; qualities required of her profession as a fine-art model. But behind, in the larger mirror, a different side of Rosa is reflected, where she looks vulnerable, exposed, and mysterious, reflecting a side that may not always be apparent in front of the camera. (Mirrors make great props and can add depth and layers to an otherwise 'flat' shot).

LIGHTING

We've already looked at the importance of lighting, on page 16, but I want to briefly outline how you can use light to set the scene. As a general guideline, low-key lighting can create a moody, mysterious look with strong areas of contrast, resulting in a portrait that's heavy with shadows and silhouettes. On the other hand, high-key lighting can create a brighter mood and convey truth and openness. In this case, I wanted to keep the mood relatively neutral, so I relied on soft, natural light streaming in through the window.

PERSPECTIVE

By perspective, I'm referring here to the placement of both the camera and the subject in order to create meaning in a scene. On page 130, I talked about how shooting from a low angle can make a subject appear more dominant and powerful, while shooting from a high angle can make a subject appear vulnerable, innocent, or subservient. Similarly, using a wide, medium, or closeup shot can tell a powerful visual story. Wide shots, for example, are great for capturing a sweeping landscape, conveying a sense of loneliness and isolation, or even freedom. A closeup shot can convey a sense of intimacy, emphasize emotion, or make a subject appear threatening. Medium shots, like the one you see on the next page, place equal importance on the environment and the subject, revealing character and emotion while also giving the viewer a sense of place and allowing the two elements to play off one other.

HOW I SHOT IT

I originally cast Rosa for the Renaissance-inspired fine-art portraits that you see on pages 66 and 67. But the space we shot in— a funky, loft-style daylight studio in Sydney, Australia—was so cool and interesting that I knew I wanted to incorporate elements of it, like the dresser and mirrors, in a few portraits. I encourage you to pay attention to your surroundings and keep your eyes peeled for cool props your subject can interact with or even for pre-existing scenes where you can insert them. Some of my favorite portraits have been thanks to a little last-minute mise-en-scène! I shot this specific portrait of Rosa on a Nikon D850 with a 50mm prime lens, using exclusively natural light.

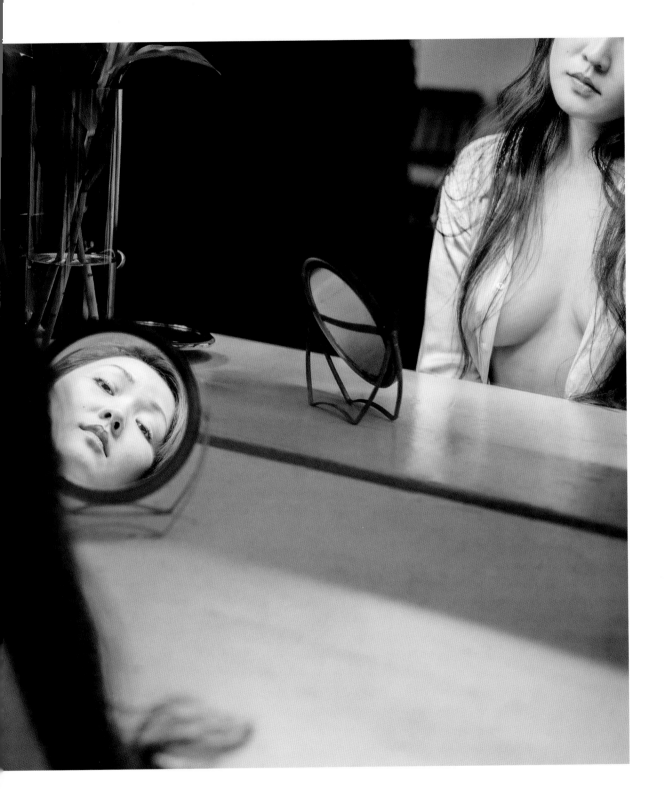

4

INSPIRATION

**INSPIRATION BOARDS
SOCIAL MEDIA
TAKE AN ART CLASS
STUDY THE MASTERS
INSTANT FILM
READ
FILM AND MOTION PICTURE
PRACTICE, PRACTICE, AND
MORE PRACTICE**

———

Being a professional photographer and visual artist who genuinely loves what I do, people often assume that I'm constantly inspired to create, that I'm a wellspring of ideas and motivation. That couldn't be further from the truth. While inspiration is absolutely necessary to create beautiful, powerful portraiture, it takes a lot of work and discipline to be (and stay) inspired. The writer William Faulkner put it best when he said: "I only write when inspiration strikes. Fortunately, it strikes at nine every morning."

I work hard to stay excited and passionate about shooting portraits and creating fresh, original images. From studying the masters before me to reading mind-opening literature, to dabbling in different art forms such as drawing and painting, I access as many different sources of inspiration as I can to fill my creative cup. Most of the portraits you see in this book are a result of my efforts to stay actively and continually inspired, which I'll go over in detail in this chapter.

INSPIRATION
BOARDS

Creating an inspiration board is arguably the easiest, cheapest, and most effective way to spark inspiration. Also called a mood board or a reference board, it's essentially a collage of ideas, references, and images that inspire you in some way. It's highly personal and there's no wrong or right way to create one. It could be a cork board where you pin photos torn from magazines, song lyrics, color swatches, or hand-drawn sketches. It can also be a digital board, like Pinterest, or a working Photoshop file on your computer's desktop, where you drag and drop inspiring images you find online.

You can put a board together for a specific reason, such as for a portrait series you want to shoot, or just create a general photography board filled with random images that you're drawn to. I have separate digital boards for portrait projects and genres of photography (nudes, black and white, studio portraits) that I'm continually adding images to. I source most of my images online and through social media (see overleaf).

In my own experience, the main benefit of putting together an inspiration board is having a centralized place to dump all of my thoughts and ideas about a specific portrait project. It helps me to work out what I want to achieve visually—not so much in a literal sense, but in terms of setting a mood, tone, and vibe.

Here, I was looking to shoot black-and-white fine-art portraits that were both Renaissance and nature-inspired, so I threw together a few ideas and references in Photoshop. Unfortunately, due to copyright issues (I don't own any of the images I've pinned on my actual inspiration boards) I've had to use my own photography and drawings to demonstrate my point, but the actual board I put together for this shoot looked very similar: a mixture of black-and-white landscapes and nature shots, a few sketches and some nudes. Remember, inspiration boards don't have to make sense to anyone but you!

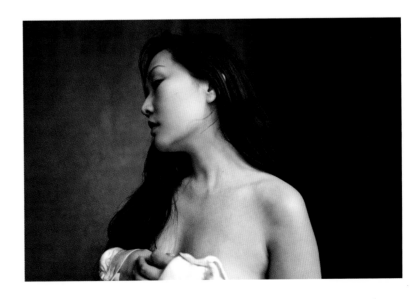

SOCIAL MEDIA

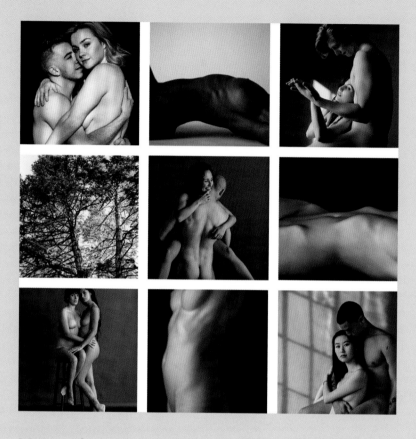

Many professional photographers have a love-hate relationship with Instagram, personally it has been a great source of inspiration for me. In fact, finding inspiration is the main reason I even use it. These days, I use Instagram purely as an artistic tool to help spark my imagination, rather than for personal or social reasons. I've even muted most of my friends and family's posts (sorry, Aunt Linda!) so that my feed is just a steady stream of thought-provoking art and imagery, rather than babies, vacation pictures, and avocado toast.

Instead, I fold it into a bit of an artistic morning ritual. At least once a day, usually in the morning after breakfast while drinking my coffee, I'll put on a relaxing playlist and spend some time scrolling through my Instagram feed—usually around 20 minutes. For me, scrolling through my feed is akin to looking at an inspiration board (see page 142), only one that refreshes daily with new images. In fact, many of the images I come upon during my morning scrolls get funneled into my actual digital inspiration boards. I can truly say that using social media in this very specific way has improved my life and inspired my art.

CURATE

Thoughtful curation, in my opinion, is the key to transforming an addictive, time-stealing app like Instagram into a tool that genuinely betters your life, your art, and mental health. As I mentioned, I've muted most accounts that are not related to art and photography and follow only accounts that I know will populate my feed with beauty and inspiration. This includes other artists, nature accounts, and museums. Because I am controlling it—as opposed to how it used to control me when I used it merely as a social app—I find that Instagram serves me positively as a source of inspiration.

DIVERSIFY

Social media tends to be an echo chamber of our own beliefs and perspectives, and Instagram, when used the way it was designed, can easily become a reflection of our own cultural and socio-economic bubbles. Because art is a reflection and expression of who we are, I believe that our art gets better as we do. So, I would implore you, as I have done myself, to flood your feed with diverse voices, particularly from BIPOC and LGBTQ+ artists, poets, writers, and photographers. I've put together a list of some incredible people that I follow on page 146 (by no means a comprehensive one).

SAVE

Instagram allows you to save posts via a small bookmark icon to the bottom right of every image. I use this feature daily to save particularly inspiring images. If you hold the icon down for a few seconds, it even allows you to save it to a collection that you can name (e.g., "Renaissance Portrait Series," "Nature Shoot," or "Black-and-White Portraits"). These saved collections effectively work as mini-inspiration boards, though as I mentioned, I also often cherry-pick images to feed into my desktop inspiration board, as Instagram is just one of many sources of inspiration.

ACCOUNTS I FOLLOW:

MUSEUMS

National Portrait Gallery:
@nationalportraitgallery
Smithsonian National
Museum of African American
History and Culture:
@nmaahc
Leslie-Lohman Museum of
Art: @leslielohmanmuseum
The Metropolitan Museum of
Art: @metmuseum
The California African
American Museum:
@caaminla
The Museum of Modern Art
(MoMA):
@themuseumofmodernart
Tate: @tate
The Guggenheim:
 @guggenheim

NATURE

Earth: @earth
National Geographic:
@natgeo
National Geographic Travel:
@natgeotravel
CNN Travel: @cnntravel
National Park Service:
@nationalparkservice

PHOTOGRAPHY AND PORTRAITURE

Diversify Photo:
@diversifyphoto
Gordon Parks Foundation:
@gordonparksfoundation
Magnum Photos:
@magnumphotos
Women Photograph:
@womenphotograph
Buzzfeed JPG:
@buzzfeedphoto

BIPOC AND LGBTQ+ ARTISTS

Ruddy Roye: @ruddyroye
Micaiah Carter:
@micaiahcarter
Dario Calmese: @dario.studio
Clifford Prince King:
@cliffordprinceking
Cassi A. Namoda:
@cas_amandaa
David Ozochukwu:
@daviduzochukwu
Zhang JiaCheng:
@lesliezhang1992
Uzo Hiramatsu:
@uzo_hiramatsu
Lia Clay Miller: @liaclay
Victoria Villasana: @villanaart
Rupi Kaur: @rupikaur_
Steph Grant: @imsteph
Queer|Art: @queerart
Photographers of Color:
@photogsofcolor

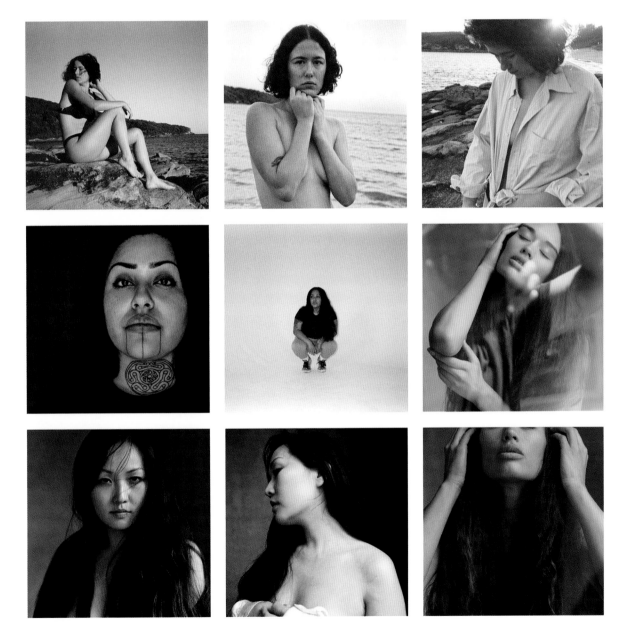

TAKE AN ART CLASS

I'm the first to admit that I'm not talented at drawing, sketching, or painting, so please forgive the very amateur sketches you see here. However, I do find that taking an online figure-drawing or painting class once or twice a month helps me to take infinitely better portraits. I can't really explain it, but picking up a pencil or a paintbrush just seems to activate a different part of my brain than a camera. When I'm holding a camera in my hands, I automatically see my subject in terms of framing, composition, posing, and angles. But when I have a pencil in my hand, I see a human being in a completely different light.

TIP

Find an online figure-drawing class (also called "life drawing") that's in your specific area. There are so many incredible classes out there, across the entire globe, and you'll likely want one that's in your time zone. Plus, if you ever decide to attend a class in person (highly recommended), you'll have that option, too. A quick Google search for life-drawing classes in your nearest city should do it; I've also found Facebook to be a good resource.

Try this quick exercise right now: look outside your window. Unless you live on a tropical island, your view is probably fairly mundane—other houses or buildings, parked cars, trees, maybe a lawn, and so on. Not especially remarkable, right? Now, pick up a pencil or a paintbrush and try to draw or paint the scene in front of you. Trying to recreate the scene with your own hand requires you to study every small detail in front of you: the soft, golden light reflecting off the car windows, a flower growing through a crack in the sidewalk, the fact that no two leaves on the trees are alike. The process of drawing and painting teaches you to *see* rather than just look.

Similarly, trying to draw or paint someone's face requires you to be acutely aware of every tiny detail—their fine eyelashes, the folds of their eyelids, the creases around their mouth, the shape of their lips—in order to replicate it with your own hand. In figure drawing, you're forced to study a human body's musculature, textures, shapes, curves, and edges. It gives you a better understanding of movement, balance, and tension. These are things that you can't fully appreciate when your camera is your only tool. With a pencil or paintbrush in your hand, it's almost impossible to view a body lazily or passively.

If my own sketches are any indication, it's not so much about the quality of the drawing itself. What you're really doing when you take a figure drawing or painting class is retraining your eye. It helps you see a living thing in natural motion and appreciate the extraordinary complexity of the human body. As you learn to see details through figure drawing and painting, you'll begin to see them everywhere. It makes you a more perceptive artist and human. This is why Disney has offered free figure drawing classes (both nude and costumed) to its animators since 1932. As artists working with human subjects, it's essential for us to study the source.

STUDY
THE
MASTERS

I'm not ashamed to say that all of my portraiture is inspired by the master artists and photographers who came before me; standing on the shoulders of giants, and all that. My environmental shots, for example, are inspired largely by the work of Henri Cartier-Bresson and Elliott Erwitt. My clean and minimalist studio style is influenced profoundly by the work of Richard Avedon, who was known for shooting his subjects in a studio, against a stark white backdrop, with black-and-white film. And my nudes? Renaissance artists Botticelli and Raphael, and the visionary Carlota Guerrero, who is on her way to becoming a modern-day master.

Whenever I feel lacking in motivation and inspiration, flipping through the books of iconic photographers (specifically Cartier-Bresson and Erwitt) always feels like I'm being jolted back to life. I highly recommend doing the same with portrait photographers and artists that speak to you. Though their sheer artistry will be enough to inspire you, I'd take it a step further and carefully study their entire bodies of work, along with other masters like Alfred Stieglitz, Ansel Adams, Gordon Parks, Diane Arbus, Philippe Halsman, Annie Leibovitz, Louis Daguerre, Francesca Woodman, Arnold Newman, Dorothea Lange, and Yousuf Karsh (by no means an exhaustive list).

Newman, for example, was one of the first photographers to practice what we now know as environmental portraiture (page 46) and much can be learned from studying his use of lighting and masterful control of elements to tell a story. Similarly, the work of Cartier-Bresson, who is widely considered as the father of street photography and photojournalism, can be examined for its tight compositions, natural frames, and exceptional timing. No matter what your primary genre, studying the works of master photographers can help shape and inform your own style of work.

If you can, I highly recommend going to your local museum and looking through the bookstore, which will typically have a well-curated selection of books by master photographers and artists. Centers for photography, such as the International Center of Photography (ICP) and the Aperture Foundation in New York, are also excellent places to go for exhibitions and events. If you have no great museums or photography centers close by, I recommend visiting Google Arts & Culture (just type it into your search engine), which gives you digital access to art from more than 2,000 museums across the world!

TIP

Do a quick Google search for "master photographers," click on the "Images" tab, and choose three photographers whose portraits speak to you the most.

Now, ask yourself:
- Why am I drawn to this photographer's images?
- What techniques have they used to create meaning in their images?
- What elements of their style would I like to incorporate into my own portraits?

INSTANT FILM

HOW I SHOT IT

I shot the following photos as part of an urban fashion editorial in New York. I was using a DSLR (Canon 1DX Mark III with a variety of lenses) for the commissioned images, but I actually ended up liking the grittier, grainier look of these instant film snaps even better. I shot them using a Pentax 67 with a Polaroid film back, which is technically not an instant film camera, but the Polaroid film back loaded with Type 55 film gave me that instant film experience, with a slightly elevated image quality.

Shooting portraits using an instant film camera is a great way to spark inspiration. For one, you're working with a limited number of shots (as with any film camera) and I'm a big believer that restrictions drive creativity. Secondly, shooting portraits with instant film forces you to take photographs more carefully and thoughtfully than you normally would, to make the most of your handful of shots. And lastly, there's something about capturing a moment and then holding it immediately in your hands that's so cool and inspiring.

Instant film portraits also look awesome. Whether you're using a classic Polaroid or a Fujifilm Instax, your portraits will have that special, filmy, retro quality about them. The photos are almost always imperfect—always a little too bright or too dark, the colors slightly off, but that's part of the beauty of instant film. They're just like memories: never perfectly clear, never entirely true-to-life, but incredibly precious.

TIP

On your next portrait shoot, take an instant-film camera with you. For every shot on your shot list, take an instant photo of it first. I find that the size restriction helps me to trim the fat and zero in on what I'm really trying to achieve visually. Plus, it's so cool to have that immediate, tangible, white-bordered photograph as a memento for future inspiration, or to give to your subject(s) as a sort of souvenir.

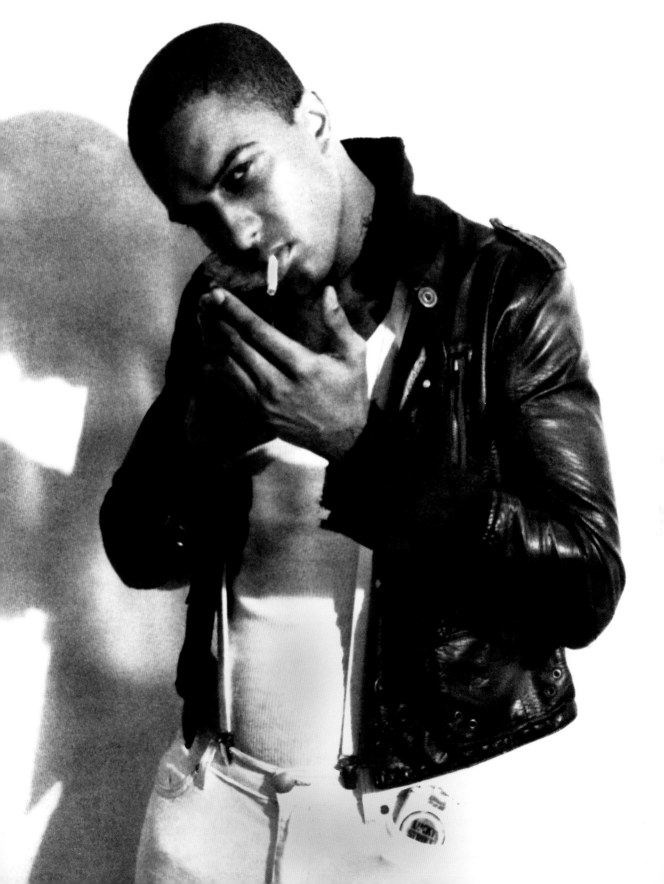

READ

People are often surprised to hear that one of the biggest sources of inspiration for my portrait work is literature. But it's true: the written word has helped me become a better visual artist. Reading memoirs and classic novels has allowed me to understand human nature more deeply and appreciate everyone's unique story. Inspirational books targeted towards artists have helped to open my mind and guide me when I'm creatively lost. Spiritual books such as *The Power of Now* by Eckhart Tolle have taught me how to stay present at every photo shoot (and in life), and not to concern myself with the results. My artistic journey is fueled by literature.

One of the books that has helped me most as a photographer is *The Artist's Way: A Spiritual Path to Higher Creativity* by Julia Cameron, which I first read about five years ago. In it, she outlines a simple creative exercise called "Morning Pages," which is to write three pages of free thought first thing upon waking. It seemed easy enough, so I folded it into my morning routine with no expectations. About a month in, I found myself writing down some really interesting stuff: new techniques I hadn't thought of before, places and people I wanted to photograph, ideas for portrait series. Recurring themes that kept popping up each day were my dissatisfaction with the fashion photography industry and my desire to photograph "real people." These thoughts eventually led to my *Ageless Beauty* photo series. The idea to write a book about portraiture even cropped up in my Morning Pages about a year ago! I highly recommend reading Cameron's entire book, but you can start this powerful exercise tomorrow.

The War of Art by Steven Pressfield is another book that has improved my art, and life, tremendously. He talks at length about the resistance we all inevitably feel as artists, which manifests in forms like procrastination, anxiety, self-doubt, and fear—and how to beat it. His thoughts on inspiration, and how we can invoke it by being disciplined and doing the work, changed my life. As an added bonus, it's so short that you can read the whole thing in one sitting.

The bottom line is that reading, like taking painting classes or studying the masters, is an incredibly effective way to spark inspiration. Memoirs and strong, protagonist-driven novels can help you to better understand human nature and all our different paths and journeys. I've said it before, but I think it's difficult to photograph people honestly and powerfully if you don't truly see them. The better you see others—and the better you know yourself—the better your art will be.

FILM AND MOTION PICTURE

Films, like books, are a huge source of artistic inspiration for me. It may not seem like it, but they can inform your portraiture in so many ways. Watching character-driven films is a great way to study movement, emotion, and the interplay of light and shadow. I also love to watch films specifically to look at framing, angles, and composition.

When re-watching classics, I often hit pause at a particularly beautiful frame and study the cinematography and the director's use of color and composition. For example, stills from many of Roger Deakins' movies could easily rank up there with the best photographs of all time. Same goes for Fellini, whose black-and-white stills feature heavily in my inspiration boards.

Shooting my own micro films—more like moving portraits—is something I like to do occasionally. I come from a family of artists and dancers (both my brother and mother were professional dancers), so I've always been drawn to capturing dancers in motion. I love that shooting movies allows me to capture all the little nuances of movement that I can't pick up, or don't translate, when shooting still portraits. And honestly, it's just fun.

Here, purely as a creative exercise, I shot a moving portrait of professional modern dancer Ayesha outside of a studio in New York. I highly recommend casting a dancer to shoot a moving portrait—they're graceful and have great body awareness—but you can shoot a moving portrait of anyone. Have your subject walk through a field or along a beach or interact with their environment (see page 46) and film them rather than take still portraits. (Always make sure you have their consent to film.) I feel like it just triggers a different part of the brain and helps me see the world in a completely different light.

TEN FILMS TO INSPIRE YOUR ART

Roma (1972 and 2018)

8½ (1963)

Blade Runner (1982)

Blade Runner 2049 (2017)

The Godfather (1972)

Moonlight (2016)

The Assassination of Jesse James by the Coward Robert Ford (2007)

Silence (2016)

Amélie (2001)

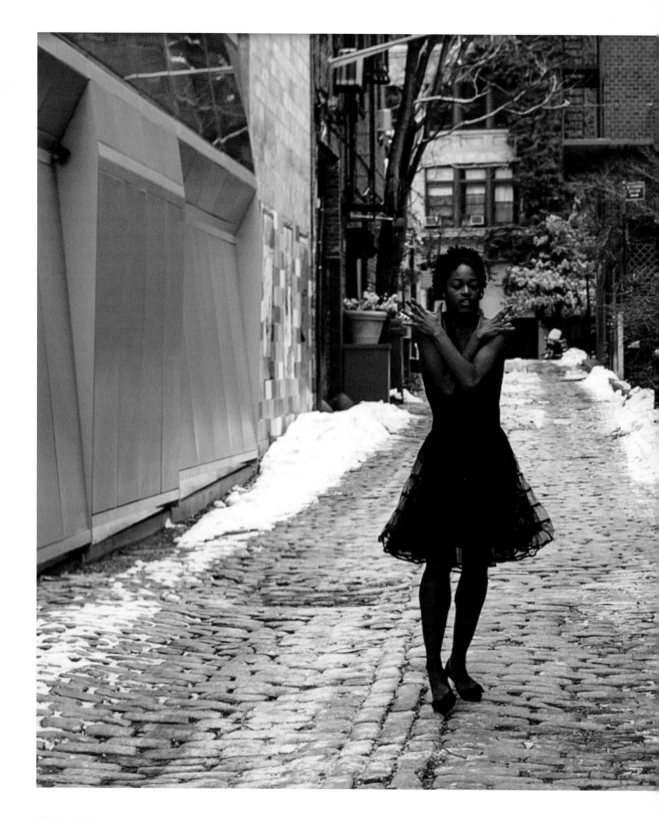

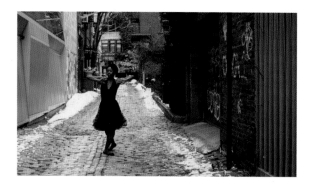
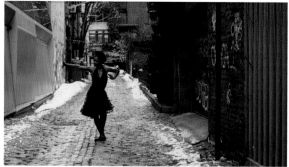
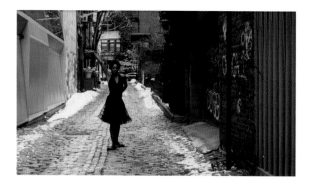
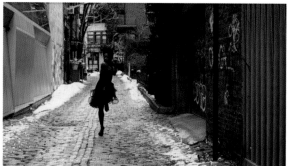

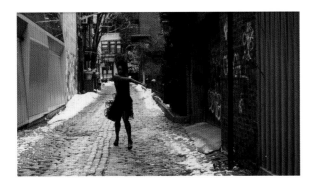

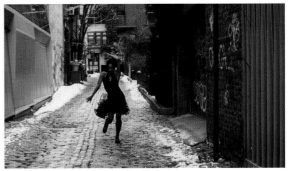

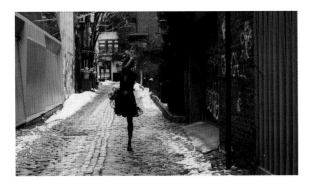

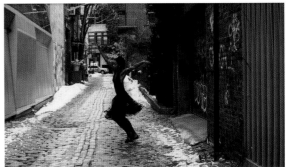

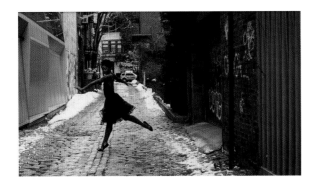

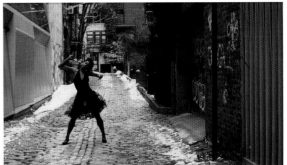

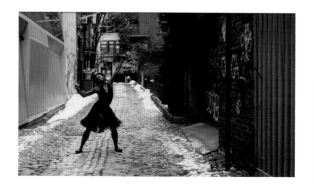 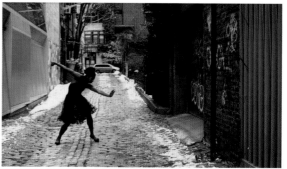

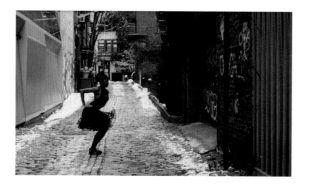 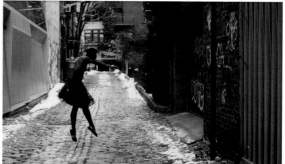

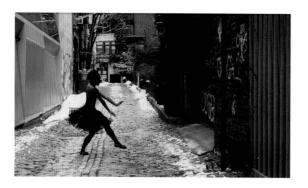 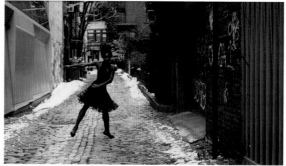

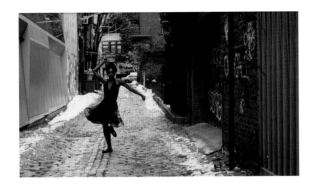

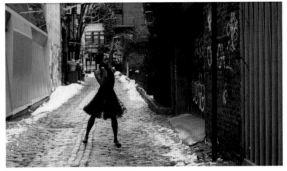

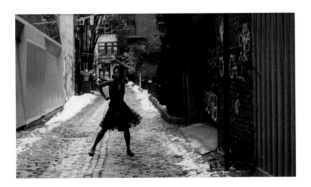

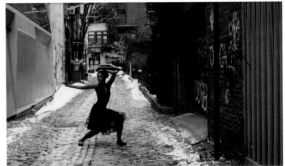

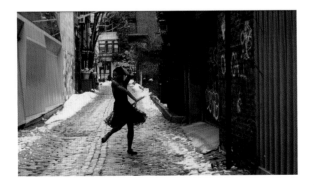

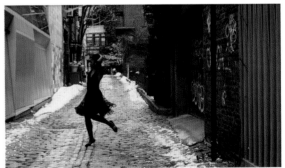

PRACTICE, PRACTICE, AND MORE PRACTICE

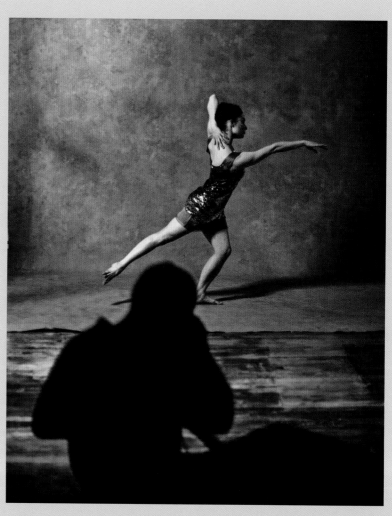

The author Malcolm Gladwell, in his book *Outliers: The Story of Success*, talks about how it takes 10,000 hours of practice to become a master in any given field. His research of successful individuals demonstrated that preparation and practice are infinitely more powerful and important than talent. He argues, in essence, that there are no "naturals," but rather excellence is a combination of talent plus practice. Lots of it.

I tend to agree with this. I believe that the only guaranteed way to take better photographs of people is to take more photographs of people. There's that saying that "nobody can do your push-ups for you." Similarly, nobody can take your portraits for you! The only way to hit 10,000 hours (aka mastery level) is to keep taking photographs. Take your camera with you everywhere; and I mean everywhere—my wife makes fun of me for taking my Leica to the grocery store. Take photos of everyone and everything, in every kind of situation, no matter how everyday or mundane. I think the everyday is where the real magic happens, anyway.

If you're lucky enough to be a professional working photographer with regularly commissioned shoots, you'll get to practice while you work. If not, act as if you are: Schedule shoots for yourself. Book out a photo studio; in major US cities, you can typically book out a studio for a half day for $250 or less. Reach out to modelling or talent agencies to see if they'd be open to lending you new talent in exchange for portraits. Don't have capital to burn? Look for some nice outdoor locations and organize some environmental shoots instead. Take portraits of your partner and your kids, neighbors, and friends. Do whatever you have to do to keep shooting regularly.

If there's one thing I know for sure, it's this: the more you work, the more inspired you get, and the better your pictures. I can't say it enough—the only guaranteed way to take better portraits of people is to take more portraits of people. So put down this book, pick up a camera, and get to it already!

ACKNOWLEDGMENTS

First, I'd like to thank all of my subjects: every single individual who has appeared in these pages and sat (or stood) in front of my camera. Capturing your portrait and hearing your story is the greatest privilege and the reason I take photographs in the first place.

Thank you to my commissioning editor Richard Collins for believing in this book about taking portraits and for supporting this project from the first day I pitched it. And thank you to Octopus for allowing me to write a third book on photography and for giving me another opportunity to share what I've learned.

Thanks to my buddies Doug Menuez and Scott Clark for sharing their experience, advice, and expertise in the genres of portraiture where I had little.

Thank you to everyone who has read my last two books and for every email, social media message, comment, question, and piece of feedback (which have all greatly helped to inform this book).

Lastly and most importantly, thank you to my wife Kris for her endless support and for being my ultimate muse and inspiration!

INDEX

An Hachette UK Company
www.hachette.co.uk

First published in the United Kingdom in 2022
by Ilex, an imprint of
Octopus Publishing Group Ltd
Carmelite House
50 Victoria Embankment
London EC4Y 0DZ
www.octopusbooks.co.uk
www.octopusbooksusa.com

Distributed in the US by Hachette Book Group
1290 Avenue of the Americas, 4th & 5th Floors,
New York, NY 101014

Distributed in Canada by Canadian Manda Group
664 Annette Street, Toronto, Ontario,
Canada M6S 2C8

Design and layout copyright
© Octopus Publishing Group Ltd 2022
Text and illustrations copyright © Demetrius Fordham 2022

Publisher: Alison Starling
Commissioning Editor: Richard Collins
Managing Editor: Rachel Silverlight
Assistant Editor: Ellen Sandford O'Neill
Art Director: Ben Gardiner
Design: Leonardo Design Studio
Production Managers: Lucy Carter and Nic Jones

ISBN 978-1-78157-824-7

A CIP catalogue record for this book is available from the British Library.

Printed and bound in China

10 9 8 7 6 5 4 3 2 1